CREATE

Beautiful

A CHIC COLORING AND ARTIST–INSPIRATION BOOK

Lola Sánchez Herrero & Ana Sánchez-Gal
Founders of The Oliver Gal Artist Co.

ROCK POINT
QUARTOKNOWS.COM
NEW YORK, NY

CONTENTS

INTRODUCTION

Oliver Gal Artist Co. is a growing art and lifestyle brand in South Florida, spearheaded by us, sisters and artists, Lola Sánchez Herrero and Ana Sánchez-Gal. We created Oliver Gal to capture life's most haute moments, avant-garde objects, and splendid lifestyles in art and other products and bring them to the people. Our company has become a worldwide phenomenon, with thousands of collectors and followers who see and buy our artwork and lifestyle products to express themselves and complement the décor of their homes.

Our inspiration is life itself. We believe art should reflect who you are, what you look up to, and where you see yourself, while complementing the space you want to unwind or create in. We strive to follow not only fashion trends but also worldwide events and happenings. We believe in art that evolves with the times, is in constant change, and reflects your personality at every stage of your life. By doing this, we have gathered a following that continues to inspire us and constantly encourage us to come up with new ideas so that we remain trendsetters instead of followers.

While making *Create Beautiful*, our number-one goal was to put together an easy, fun, and inspiring guide for those who want to create art, but perhaps have no formal training—artists at heart who want to experiment, but may feel intimidated by the numerous tools and materials available at arts-and-crafts stores and the plethora of online tutorial videos that can contradict one another with the information they share.

The purpose of this book is not to give formal or technical training; on the contrary, it is intended for you to experiment, and to encourage and inspire you to create and express yourself artistically, liberated from the established rules, thanks to the tips and techniques that you'll find throughout its pages—a jumping-off point, so to speak.

Overall, we want you to have fun, because there is no right or wrong way to create beautiful!

HOW TO USE THIS BOOK

You can read this book from cover to cover for inspiration, open it up to a step-by-step project in the Create section that catches your eye, or just color the pages in the Color section for a relaxing activity.

The sections in the front of the book explain the tools and materials that we used to make the step-by-step projects. Our goal here is to help take the guesswork out of what you need to buy to get started making art. From there, we show you how to create your ideal workspace, and we have also included a gallery of color palettes to inspire you not only when creating the projects in this book, but also for adding a splash of color to your life.

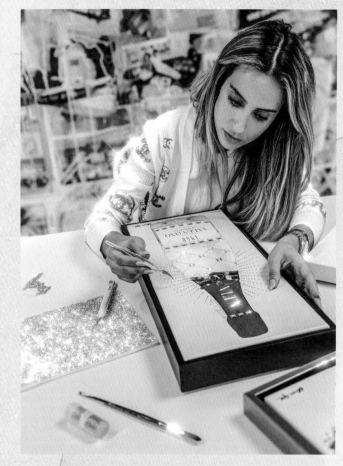

With the sixteen step-by-step tutorials in the Create section, we share some of our favorite techniques for creating art, all while making beautiful, finished pieces. The projects on pages 29 to 73 are ones that you create from scratch, and include painting, dripping, pouring, and collage techniques. The projects on pages 79 to 91 are a little easier, as they use templates of signature Oliver Gal artworks for you to embellish with gold leaf, glitter, rhinestones, and diamond dust. These templates are in the back of the book and perforated to easily tear out. For practical purposes, all of the tutorials are smaller in scale and are recommended to be made on either art paper or the provided templates, but once you get the hang of things, you can always apply the techniques to a larger canvas, and even your own ideas.

The Color section of the book has twenty-four fun and glamourous coloring pages. Here, you can also experiment with the techniques we show you with the projects in the Create section, or you can just do some relaxing coloring. There are no rules!

TOOLS

These are the tools that you will commonly see used throughout the projects in this book. You don't need to buy everything listed here all at once. Each project has a materials list that will guide you in what you need to have on hand. Throughout the book, we suggest our preferred brands, but if you can't find the exact items, substitutes are welcome, and you may find things that you like even better.

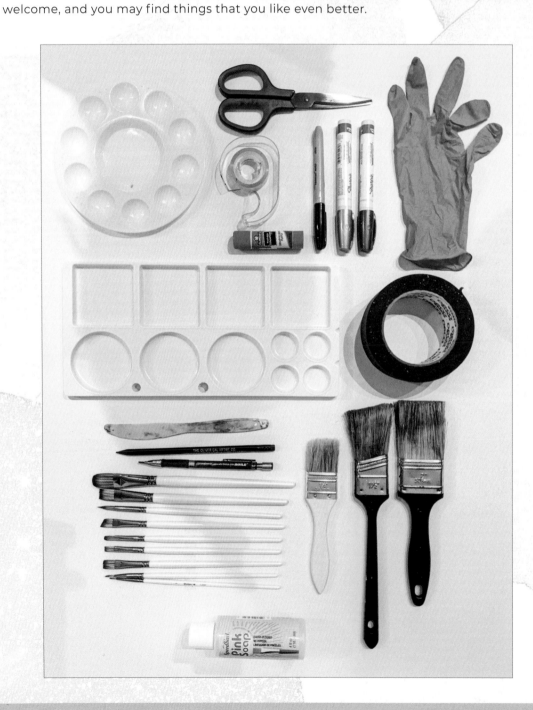

BLACK SHARPIE

A high-quality permanent marker is good to have on hand. We use it to label paint containers and make markings on a surface that doesn't allow pencil, among other things.

GLUE

There are three types of glue we recommend: Mod Podge or Elmer's School or Clear Glue for general use; a glue stick (preferably Elmer's brand) for making collages with magazine pages; and a glue gun for affixing larger, heavier embellishments and creating textures in resin.

METALLIC PAINT PENS

These oil-based pens are great for painting over dried resin, adding details and accents, and writing calligraphic text. For metallic gold, we like the Pilot Creative Permanent Marker with a medium tip. The metallic gold and silver Sharpie Oil-Based Paint Markers also work well.

PAINTBRUSH CLEANER

A brush cleaner is necessary for maintaining your paintbrushes and helping them last longer. We like Speedball Pink Soap for soaking brushes and easy, fast cleaning.

PAINTBRUSHES

See page 16 for more information on paintbrushes.

PALETTE KNIFE

Any plastic knife will do for creating interesting textures and stirring paint when it separates. This is a good opportunity to use up all those plastic knives that often come with takeout food.

PALETTES

We prefer to use plastic palettes for mixing paint colors, but if you want a quick and easy cleanup, there is also disposable palette paper (see page 9).

PENCILS

Pencils are great for sketching ideas, as well as drafting elements on a canvas before painting it or affixing embellishments to it. There are many types available, so this is a personal preference. And where there's a pencil, there should be an eraser. We like to use Staedtler Mars plastic erasers because they're not too abrasive and won't damage paper or canvas.

TIP

If you don't have Mod Podge, you can make it by mixing two-thirds Elmer's School Glue with one-third water.

RUBBER GLOVES

These are necessary to keep your hands clean and to manipulate resin or paint.

PAPER TYPES

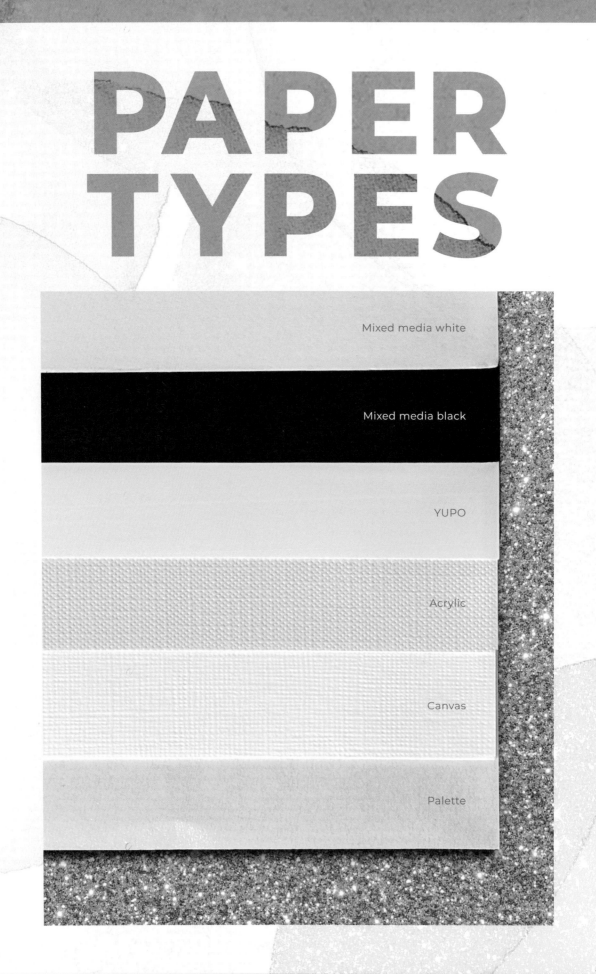

Mixed media white

Mixed media black

YUPO

Acrylic

Canvas

Palette

When buying paper for your projects, you want a heavyweight paper that will work with your chosen medium. Like with all arts-and-crafts materials, art paper has varying degrees of quality and price points, from student quality for practicing to acid-free for creating long-lasting works of art. The paper types we describe in this section are the most suitable for the projects in this book. We prefer buying pads of paper instead of spiral-bound or loose paper because of their ease of use with their glue-bound pages.

ACRYLIC
This off-white, heavyweight paper has a linen finish that mimics the surface of a traditional canvas, and as its name implies, is great for acrylic painting.

CANVAS
This is a canvas-textured paper for oil and acrylic painting. You can also use it with any other mediums if you like that linen-like texture.

MIXED MEDIA
This white, heavyweight paper with a vellum surface is versatile and works with a number of mediums. You can also purchase this paper in black to create modern and bold artworks.

PALETTE
This smooth, poly-coated paper can be used for mixing paint. Though not the most eco-friendly option, it makes for easy cleanup, as you can just throw it away when you're finished.

WATERCOLOR
There are myriad options when it comes to watercolor paper, including different weights and quality. Its composition of cotton is what makes it more absorbent than other papers to handle the watercolor medium.

YUPO
This synthetic paper is made of 100 percent polypropylene, making it waterproof, nonabsorbent, water-repellent, stain-resistant, and extremely durable. It is smooth and works especially well for alcohol inks and other aqueous mediums. And it's forgiving! You can wipe off any mistakes when working with a water-soluble medium.

When using textured art paper, make sure that the top, or textured, side is facing up and is the side you're working on. This side is called the felt side and the back side is the wire side.

PAINT TYPES

These are the different paint types we like to use in our professional projects. We don't use all of these in the projects in this book, but we wanted to educate you about the different options you may come across when you're shopping for art supplies. Again, don't be afraid to experiment!

ACRYLIC GOUACHE

This matte acrylic paint is called gouache because it looks similar to it, but unlike traditional gouache, it dries waterproof. It can be achieved by mixing any regular acrylic paint with one of the acrylic mediums discussed on page 13.

ACRYLIC INK AND HIGH FLOW ACRYLIC

These types of acrylic paint have a water-like consistency but the same paint depth and opacity of regular acrylic paint. Acrylic ink can be used in pens for drawing and calligraphy because it has finer pigments than the high flow version. High flow acrylic is great for dripping and splattering. For the projects in this book, you can use either one.

ACRYLIC PAINT

Acrylic paint is our favorite paint medium! This popular and easy-to-use paint has a polymer mixed into it, which gives it a thicker texture and makes it waterproof once dry. It is very adhesive, so you can paint on different surfaces with it and it won't come off. It is also flexible (see Acrylic Paint Mediums on page 13). The only downside to acrylic paint is that it can dry quickly on the palette and is not reworkable with water, so dispense small amounts onto your palette and add more if needed. Our preferred brands of acrylic paint are Martha Stewart Multi-Surface Satin Acrylic Paints and Liquitex acrylics.

ALCOHOL INK

We use alcohol ink to create beautiful ethereal-looking landscapes on YUPO paper (see page 9) and to color resin. To blend these, you will also need 90 percent isopropyl alcohol, the kind that you can buy at a pharmacy or supermarket, or an alcohol blending solution. Ranger Tim Holtz Alcohol Ink sets are perfect to start with.

COLORED PENCILS

These are not necessarily paint, but we like to use these when coloring to relax. We also bring them with us when we travel, because they are less messy than acrylic paints. Colored pencils have a wax- or oil-based binder, so they become a bit water-repellent when applied.

GOUACHE

Gouache is opaquer than watercolor paint due to white pigment or chalk added to it when it is made. Think of it as a muddy watercolor. To make it lighter, add more white gouache to it.

INDIA INK

Traditionally used for calligraphy, India ink is great for fabric dyes, to make drips over acrylic paint, and to add more intense colors to a watercolor piece.

PASTELS

Pastels come in a stick form and feel like soft chalk. Their consistency allows you to scribble with them over dried acrylic paint, which gives your work a modern-art vibe. They also melt easily and are fun to blend. We use these to finish a lot of our abstract pieces.

POURING ACRYLIC

These acrylics come prediluted with a marbling solution that allows you to create marbleized, swirl-filled abstracts without having to mix it yourself.

WATERCOLOR PAINT

Watercolor is the most transparent of the paints, and the easiest one to lighten and mix. It isn't waterproof once dried; it is resoluble, so if you add water to dried paint, you can rework it time and time again. To make it more transparent, add water.

To see how some of these different paint types look when painted on a piece of mixed media paper, go to the next page.

TIP

If you're looking to create richer or darker tones, you will want to purchase a brand or line that has more pigment, which makes these paints more expensive.

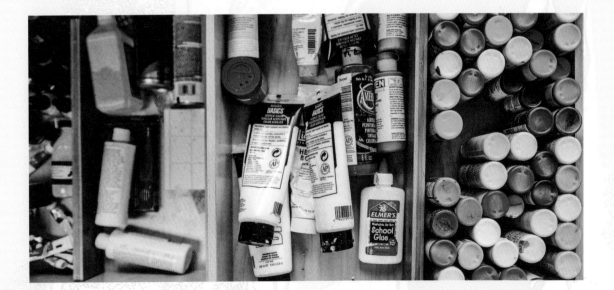

Below, we have labeled swatches of paint to show you how different paints and brands look on a piece of mixed media paper.

Dr. Ph. Martin's
Bombay India Ink

Martha Stewart
Multi-Surface Satin
Acrylic Craft Paint

Delta Creative
Ceramcoat Glow in
the Dark Acrylic

Liquitex Acrylic
Gouache

Daler-Rowney FW
Acrylic Artists Ink

FolkArt Pure Artist
Pigment Heavy
Bodied Acrylic Paint

Martha Stewart
Soft Gel Watercolor
Acrylic Craft Paint

Arteza Pouring
Acrylic Paint

Golden Fluid
Acrylics

Craft Smart
Acrylic Paint

FolkArt Acrylic
Paint

DecoArt Americana
Acrylic Paint

Craft Smart Multi-Surface
Premium Satin
Acrylic Paint

Prismacolor
Premier Colored
Pencil

Golden High Flow
Acrylics

Ranger Tim Holtz
Alcohol Ink

ACRYLIC PAINT MEDIUMS

Acrylic paint is our favorite paint because it is the most flexible to work with. Thanks to acrylic mediums, you can change the consistency, viscosity, flow, elasticity, and drying time of the paint, giving it the qualities of other paint types discussed on page 10, but with the advantages of acrylic paint.

In the image below, we mixed blue paint with five mediums to achieve different consistencies and sheens. There are a lot of acrylic mediums available, but we have found that the Liquitex Basics Acrylic Starter Set, which we used here, includes enough variation to create textured and interesting compositions.

Iridescent

Modeling paste

Gloss gel

Gesso

Course texture paste

METALLIC ACRYLIC PAINTS

If you are familiar with Oliver Gal, you know that metallics and jewel tones are our way of embellishing and elevating our pieces. For that, we need to know how metallic paint is going to look when it has dried and settled. But not all metallic paints are created equal, and they don't look the same when applied onto canvas textured paper.

On these two pages, we have compiled swatches of different metallic paints, so you can judge for yourself what you like. Our favorite is the Mont Marte Premium Gold Foil Paint, even though it comes in a small bottle. But as you can see, it is almost reflective, and it has low fumes and is perfect for a finishing metallic accent. It works great on plastic, paper, canvas, and when pouring paint, and comes in silver too. Our runner-up is Golden Fluid Acrylics in Iridescent Gold Deep because of its warmer shade.

FolkArt Multi-Surface
Metallic Acrylic Paint
in Bright Gold

FolkArt Multi-Surface
Metallic Acrylic Paint
in Taupe

FolkArt Brushed
Metal Acrylic Paint
in Antique Gold

FolkArt Brushed
Metal Acrylic Paint
in Bronze

Daler-Rowney FW
Acrylic Artists Ink
in Gold

Golden Fluid Acrylics
in Iridescent
Gold Deep

Modern Masters
Matte Metallic Paint
in Olympic Gold

Craft Smart Premium
Gilding Paint
in Classic Gold

Liquitex Professional
Acrylic Ink! in
Iridescent Rich Bronze

Mont Marte Premium
Gold Foil Paint

Martha Stewart
Multi-Surface Metallic
Craft Paint in Gold

DecoArt Americana
Decor Metallics
in Vintage Brass

DecoArt Americana
Decor Matte Metallics
in Champagne

FolkArt Multi-Surface
Metallic Acrylic Paint
in Silver Sterling

Liquitex Basics
Acrylic in Gold

Liquitex Basics
Acrylic in Silver

PAINT BRUSHES

We recommend buying nylon paintbrushes for the projects in this book. They are inexpensive and versatile, especially when working with acrylic paint and other mediums. They also quickly recover their shape and don't shed. Paintbrushes come in different shapes and sizes, with the size of the brush printed on the handle (the larger the number, the larger the brush). For smaller brushes, we suggest buying a set with a variety of shapes and sizes, such as DUGATO's 10-Piece Artist Paint Brush Set. Classic hog hair brushes are inexpensive and perfect for painting large areas or projects in which you want the "brushstroke" to be evident and leave a textured trace.

Here we've demonstrated a variety of paintbrushes and their brushstrokes for your reference.

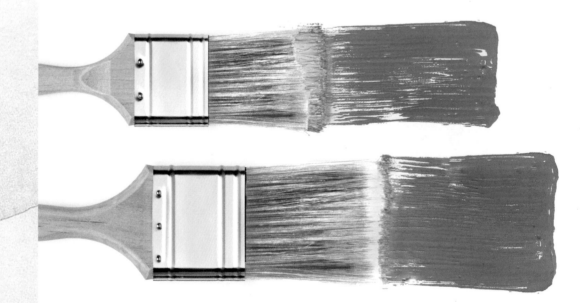

Top: 1½-inch (4 cm) flat hog bristle brush for large, bold strokes and covering large areas with paint.
Bottom: 2-inch (5 cm) flat hog bristle brush for large, bold strokes and covering large areas with paint.

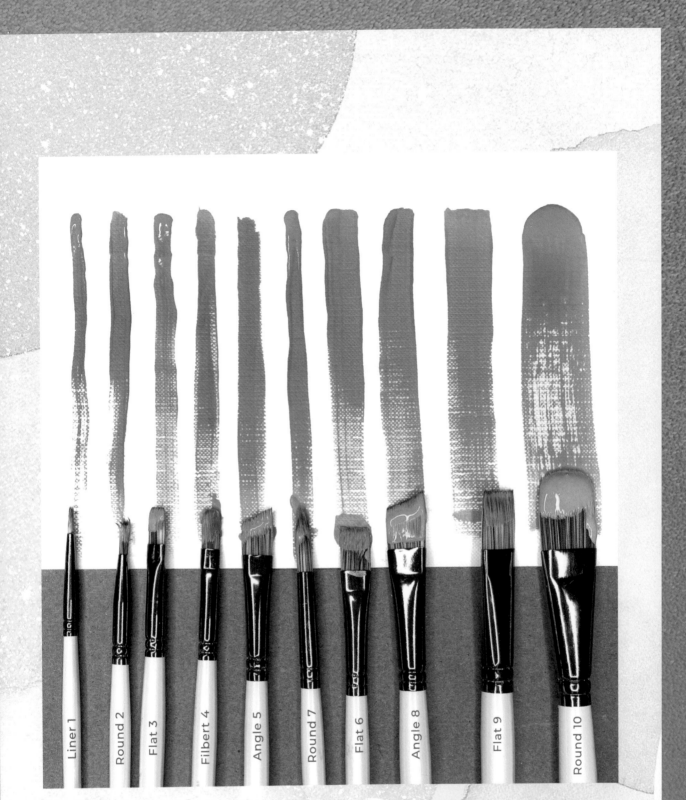

From left to right: #1 liner nylon brush for fine lines, details, and lettering; **#2 round** nylon brush for details and short strokes; **#3 flat** nylon brush for bold strokes and filling in; **#4 filbert** nylon brush for blending edges; **#5 angle** nylon brush for detail coverage; **#7 round** nylon brush for details and short strokes; **#6 flat** nylon brush for bold strokes and filling in; **#8 angle** nylon brush for painting details; **#9 flat** nylon brush for bold strokes and filling in; **#10 flat** nylon brush for bold strokes and filling in.

EMBELLISHMENTS

Instead of paint, these embellishments are used to create some of the projects in this book, while others are used to, well, embellish them.

DIAMOND DUST

Diamond dust is white German glass glitter that is actually made of crushed glass. We prefer to use diamond dust with a 90 to 100 grit (grain size), and like to apply it as a varnishing layer over a piece of art to make it sparkle all over. A good substitute for this is extra-fine transparent glitter.

GLITTER

Everyone loves glitter! These sparkling particles are most commonly made from sheets of metallized plastic film, which is then cut into octagons and hexagons, making it a microplastic. The most well-known type is polyester glitter, which is made out of polyester and is shinier and long-lasting. Regular craft glitter is made of cellophane and PVC, and biodegradable glitter is made from plant cellulose. While this last one is the hardest one to find and the most expensive, it is the only form of glitter that doesn't contain plastic. We suggest using bio-glitter when possible and recycling any glitter leftovers as plastic when using regular glitter.

The size of the particles is a differentiating factor when it comes to glitter, and particle sizes range from ultrafine (0.2 mm) to large (1.5 mm), with extra-fine (0.4 mm), very fine (0.6 mm), and regular (1 mm) sizes in between. We prefer to use extra-fine and ultrafine glitter almost exclusively. It has a nicer finished look to it than the regular-size particles. We find that the best way to buy glitter is to look for a set with a variety of colors.

GOLD LEAF

Gold leaf is ultrafine sheets of metallized paper that can be made with authentic precious metals, such as silver or gold, or it can be imitation. For arts-and-crafts projects, We recommend using imitation gold leaf because the final look is identical to the real thing. Also, during learning and experimenting, a lot of material can be wasted, making it a very expensive medium. Gold leaf gives a vintage, realistic look of gold or silver to an artwork. It comes in booklets that need to be handled with the utmost care. It also requires its own set of tools and special glue. You can try out gold leafing and see the additional materials you will need to work with it in the project on page 79.

RHINESTONES

Rhinestones are gem-like particles made from simulated crystal or hard polymers that have been faceted, cut, and polished, like gems for jewelry, and are used for crafting. You can find different sizes, ranging from 1.5 to 5 millimeters, and some with flat backs or round backs. Some types have adhesive like a sticker, and other types need to be applied with a hot glue gun. We use them in our artwork to add additional sparkle. Our favorite rhinestones are Swarovski Create Your Style Flat Back Crystals.

TIP

The particle sizes of glitter can vary depending on the manufacturer, so it is better to follow the actual measurement of the particles in millimeters.

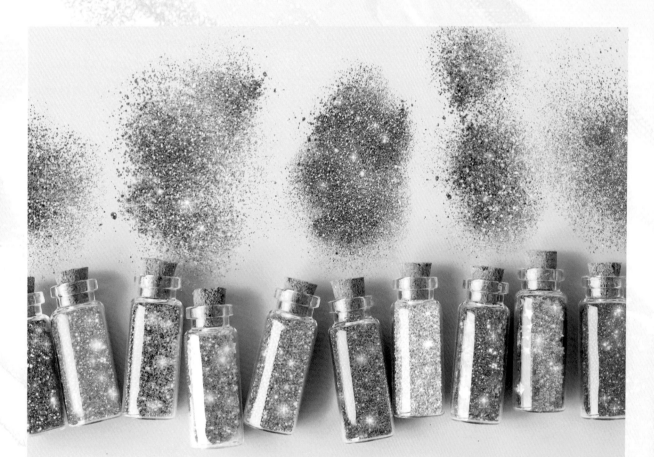

PREPARING YOUR WORKSPACE

Creating an organized workspace before starting any project will make the process a whole lot easier. Here are some helpful tips that will have you spending less time prepping and more time creating.

- Protect the table or flat surface with a reusable plastic tablecloth, recycled paper, or old newspapers. Tape the edges together with painter's tape and make sure not to leave any small spaces that might get covered in paint or other media. You may also want a tarp or plastic wrap on hand when working with glitter or diamond dust.

- Organize your paints by color groups so that they're easy to find (i.e., warm and cool colors, from light to dark).

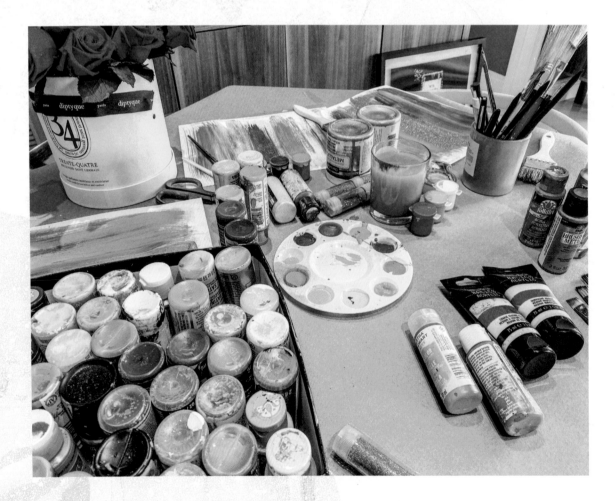

 Tape down your artist's paper with painter's tape to prevent it from moving. To keep your paper extra secure, tape around the entire piece of paper, keeping an even margin on all sides (the beautiful white space around the art). Do not remove the tape until you are sure that the paint is dry to avoid smudges. If you don't want to tape around the entire piece of paper, you can also just tape the corners to help prevent slippage.

● Prepare two cups filled with clear tap water—one for light paint colors and one for dark colors. You will use these to clean your paintbrushes between color changes. Have a cotton rag or paper towel on hand for blotting and drying your brush. When using a paintbrush to apply glue, make sure to use a paintbrush cleaner (see page 7) and water to clean the brush.

● Start making art!

TIP

Tear 4-inch-long (10 cm) tape segments and adhere them to your forearm before taping them to the paper in order to reduce the strength of the tape and make it easier to remove when the art is finished and the paint has dried.

COLOR INSPIRATION

In this section, we have shared some of ur favorite color palettes—and even given them fun names—to use in home décor and decorative art. We hope they inspire you to play with color. If you want to generate your own color palettes, try out an online tool or app such as Coolors.

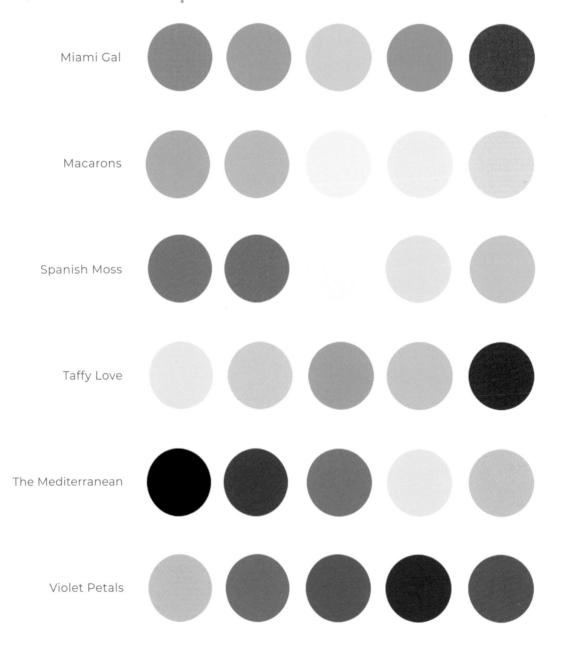

Miami Gal

Macarons

Spanish Moss

Taffy Love

The Mediterranean

Violet Petals

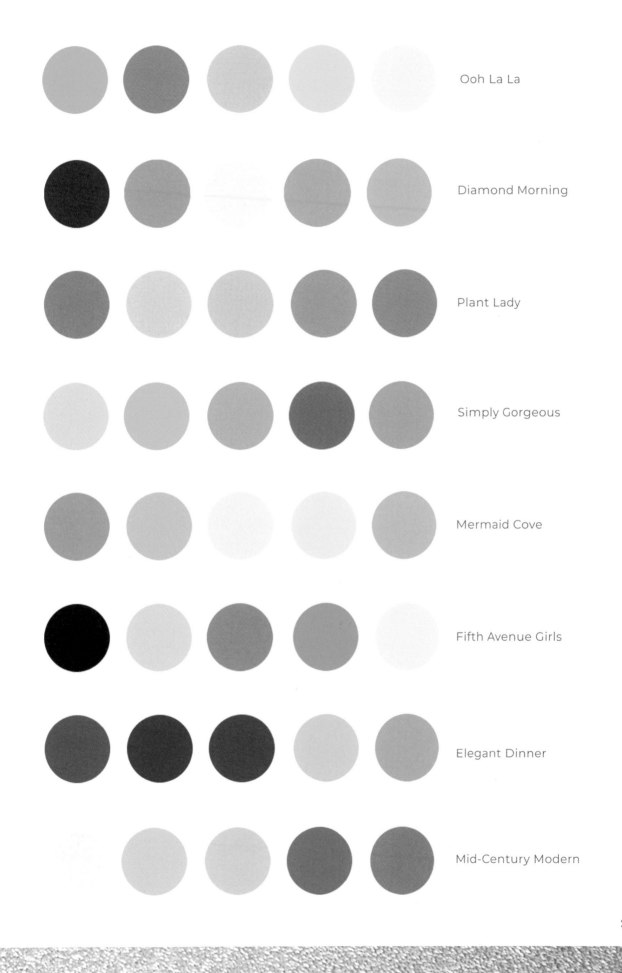

Ooh La La

Diamond Morning

Plant Lady

Simply Gorgeous

Mermaid Cove

Fifth Avenue Girls

Elegant Dinner

Mid-Century Modern

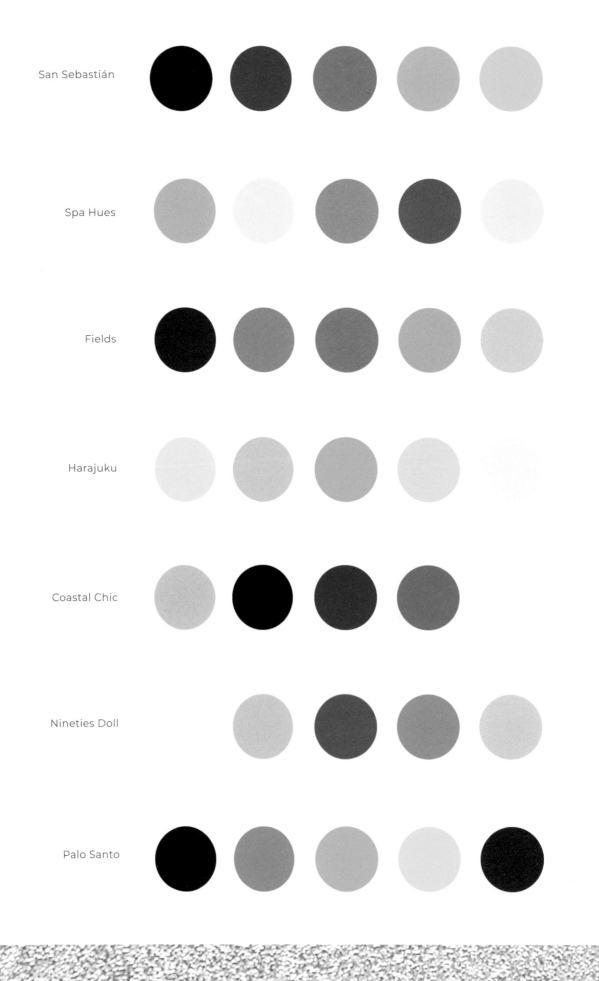

San Sebastián

Spa Hues

Fields

Harajuku

Coastal Chic

Nineties Doll

Palo Santo

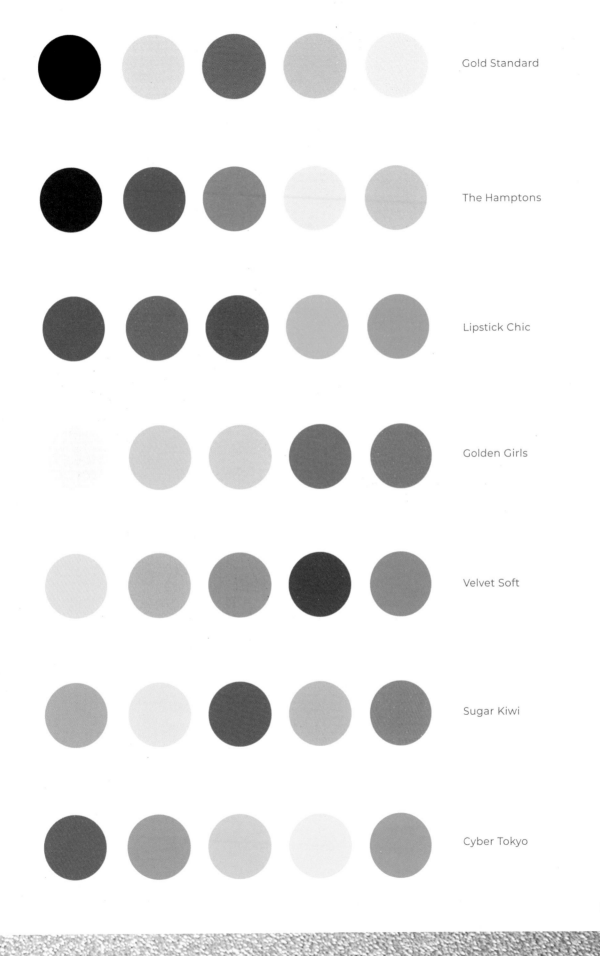

Gold Standard

The Hamptons

Lipstick Chic

Golden Girls

Velvet Soft

Sugar Kiwi

Cyber Tokyo

25

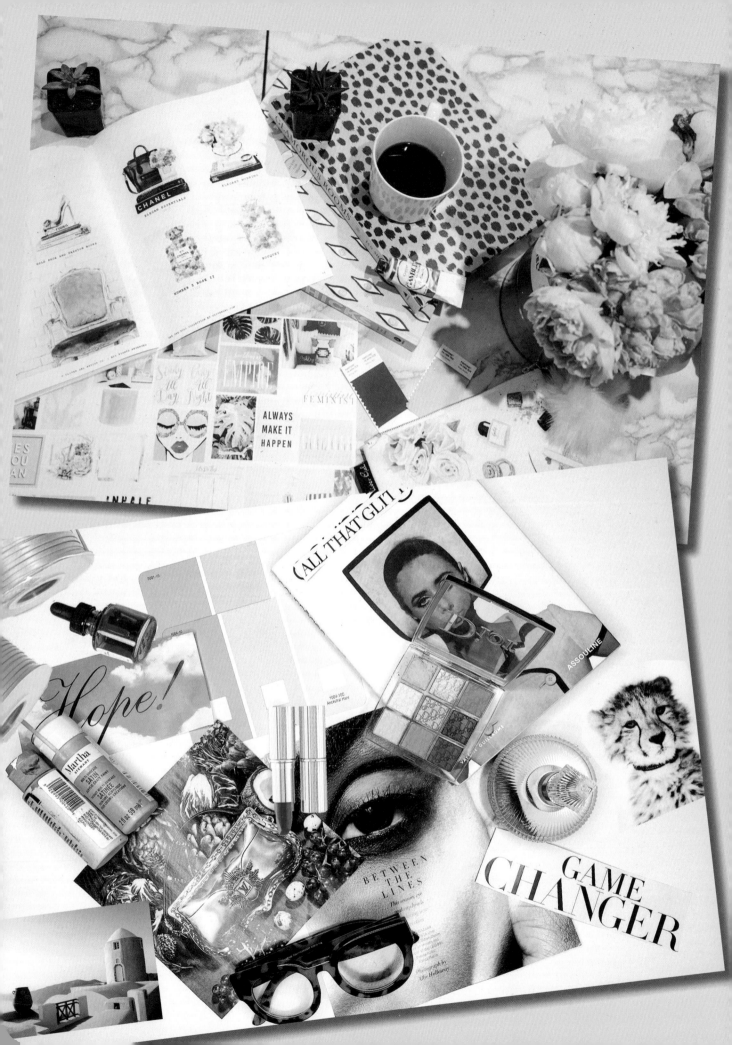

Mood Board

MATERIALS

- ✓ Background surface (e.g., large table, beautiful tile, or countertop)

- ✓ Paint swatches (from a hardware store)

- ✓ Craft materials (e.g., paint tubes, glitter containers, colored pencils, markers, etc.)

- ✓ Visual references (e.g., magazine cutouts representing color and/or mood of scene, including people, words, quotes, objects, clothing, etc.)

- ✓ Small decorative objects in the color palette and/or mood (e.g., lipstick, quartz crystals, flowers or petals, small books, figurines, candy, etc.)

- ✓ Embellishments (glitter, diamond dust, rhinestones, etc.)

- ✓ Optional decorative elements (e.g., fabric swatches, ribbon, feathers, etc.)

Online pin boards have heightened the popularity of mood boards, but there is nothing like creating one in real life. While most mood boards are made by pinning images onto a corkboard, we find it more creative to work with objects and create a 3-D flatlay (an overhead or three-quarter photo of elements laid beautifully on a flat surface) of what you are trying to convey, whether it's an idea, a feeling, or a theme.

1 Choose a background for your mood board. Since you won't be affixing the elements permanently, you want to find a well-lit area to place your composition. This will ensure a perfect picture when you are done.

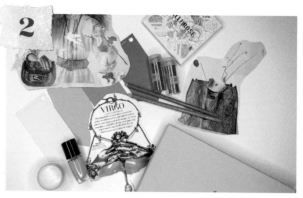

2 Place the paint swatches in the center of the background to set the tone and palette for the composition. Place the craft materials around and overlapping the swatches. You want your placement of items to be askew to give your board visual interest and energy. Continue by adding your visual references, using them as anchor points for your board. Overlap these images and place them randomly around the scene. Lay your small decorative objects as connecting points between the images and paint swatches.

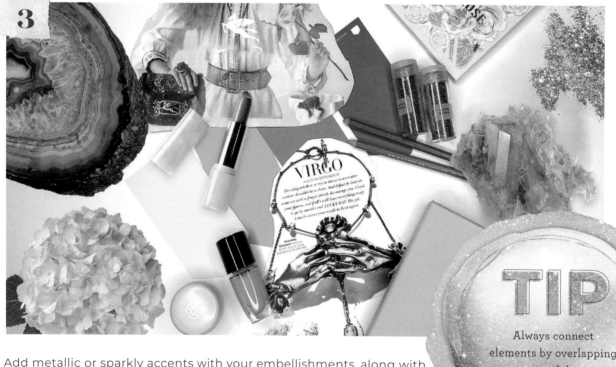

3 Add metallic or sparkly accents with your embellishments, along with any additional decorative elements, such as tossing a ribbon onto the bottom of the scene and letting it curl over some of the elements. Take a picture from overhead or at a three-quarter angle to capture your final mood board. Change the theme and repeat!

TIP
Always connect elements by overlapping a part of them.

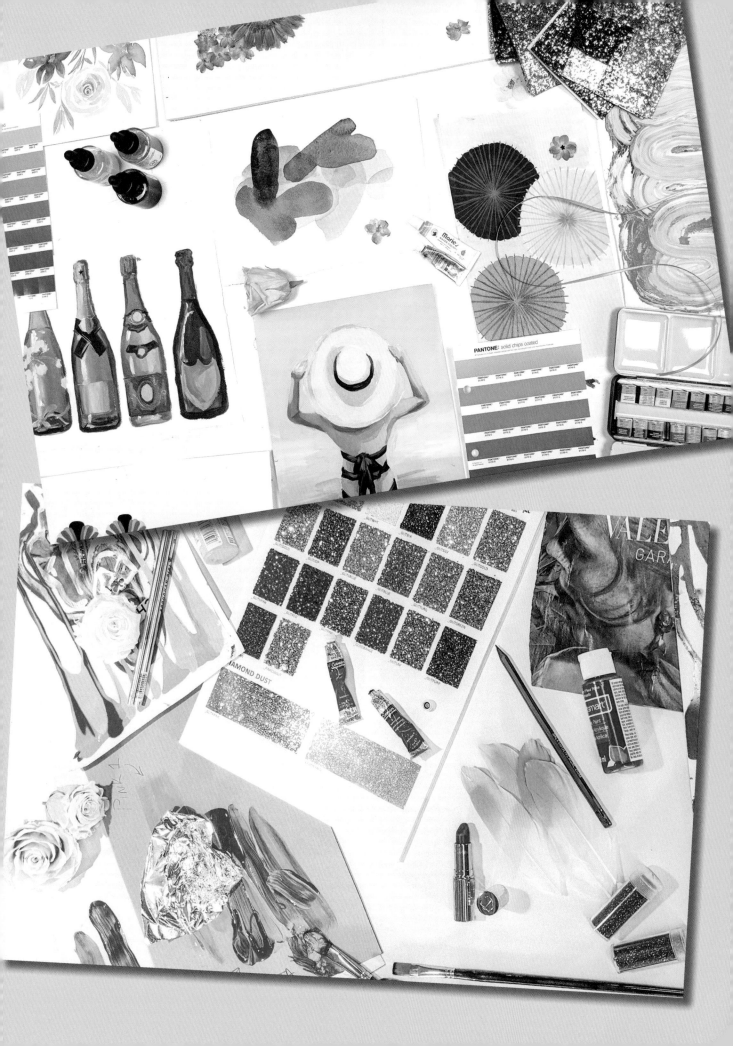

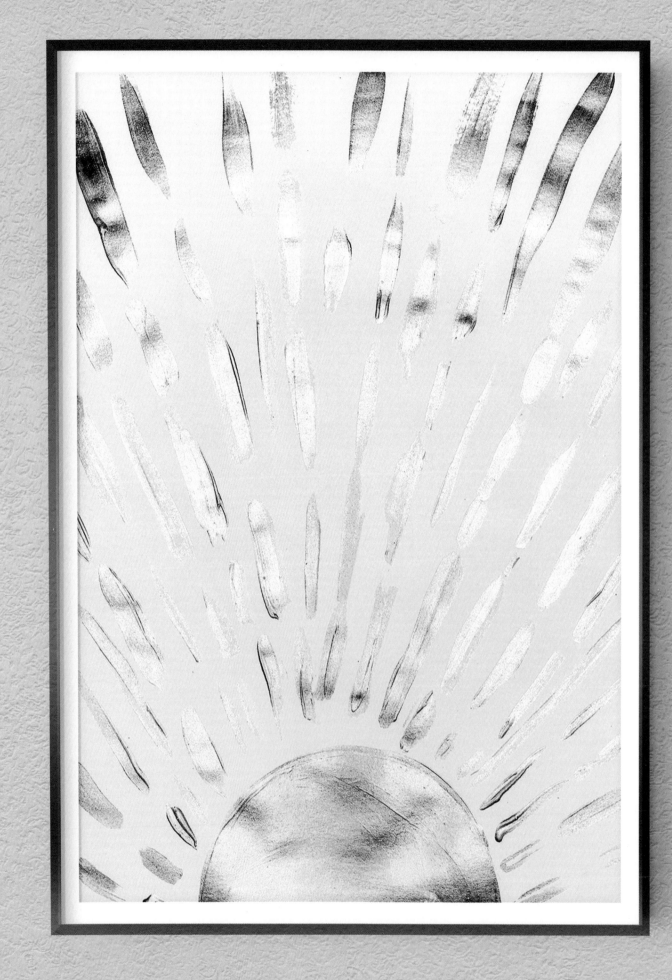

Rising Sun

MATERIALS

- ✓ 9 x 12-inch (23 x 30 cm) acrylic paper

- ✓ Painter's tape roll and/or a round object to use as a stencil (approximately 4 inches, or 10 cm, in diameter)

- ✓ Pencil (for drafting)

- ✓ Eraser

- ✓ Metallic gold acrylic paint of your choice

- ✓ Palette (plastic or paper)

- ✓ #4 filbert nylon brush

Never miss a sunrise with this glowing beauty that is sure to brighten any room. This quick and easy project only requires your favorite metallic acrylic paint. To learn more about the various metallic gold acrylic paints, see page 14.

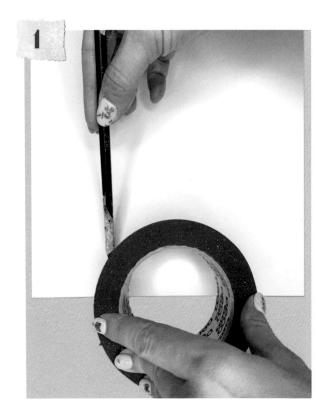

1 Lay your paper vertically on your prepared workspace and tape it down if you feel it slipping. Place your painter's tape roll at the bottom center of the paper so that you can trace a semicircle around it. Use your pencil to trace the semicircle.

TIP

Try a color variation by adding a background color before step 1. To do this, cover the entire surface of the paper with a solid color using a #10 flat nylon brush. Let it dry for at least 1 hour, and then use a metallic color to paint the rays.

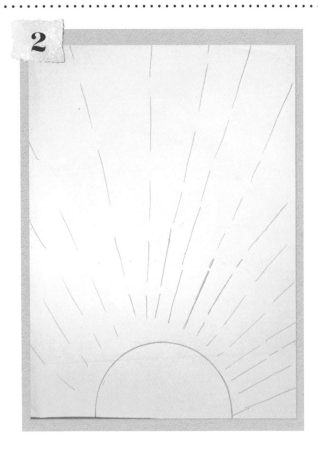

2 Draw the sunrays with your pencil by sketching dashed lines of varying lengths, extending from the semicircle to the sides and top of the paper. Avoid making these radial lines parallel to one another, but try to keep a similar distance between them. Erase some of the lines so that the dashes are uneven and irregular. Make sure to shake all the eraser debris off the paper before beginning to paint.

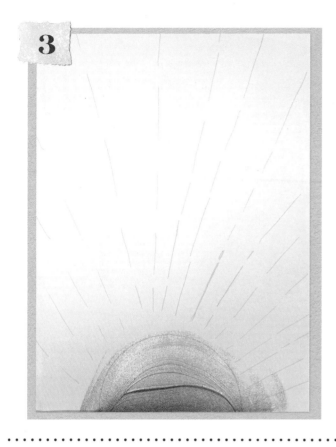

3

Squeeze about 2 tablespoons (30 ml) of metallic gold paint onto the palette and dip the tip of the brush into it. Start filling in the semicircular sun, slowly working around the edges so the shape stays as round as possible. Your goal is not to seek perfection but a handmade look. Cover your penciled outline with paint so it isn't visible.

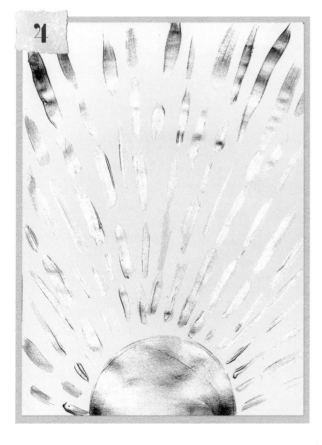

4

Cover the sunray pencil dashes with the same metallic paint in straight brushstrokes of about the same width. Make sure to cover all the dashes so no pencil lines are visible. Let your artwork dry for at least 1 day.

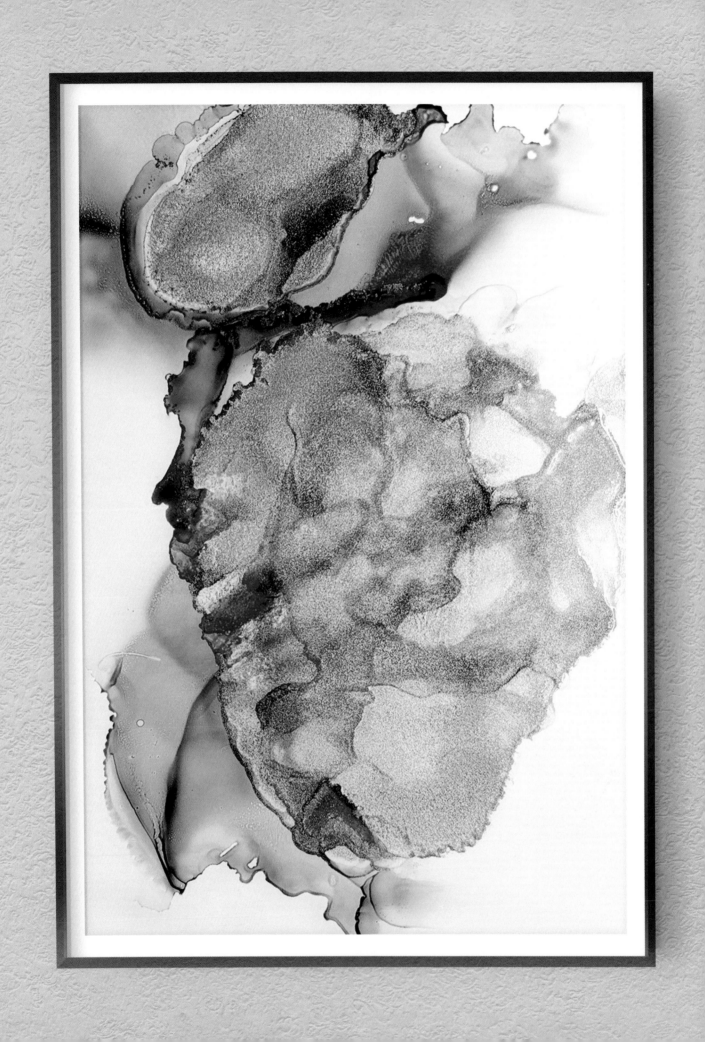

Alcohol Inks Abstract

MATERIALS

- ✓ 90% isopropyl alcohol or alcohol blending solution

- ✓ Small, empty spray bottle (a travel-size one is perfect!)

- ✓ Tarp, plastic tablecloth, or plastic wrap (to cover your workspace) or an aluminum baking tray (to place the paper in to contain dripping ink)

- ✓ Rubber gloves (to protect your hands—these dyes are incredibly staining)

- ✓ 5 x 7-inch (12.5 x 18 cm) YUPO or 100% polypropylene paper

- ✓ 3 alcohol ink colors (we used Brea Reese Alcohol Inks in Purple, Lavender, and Fog)

- ✓ Pipette (if the inks lack a dripper top; optional)

- ✓ Straw or a small rubber air blower (to blow the inks into organic shapes)

- ✓ Ranger Tim Holtz Gold Metallic Mixative or Jacquard Piñata Color Ink in Rich Gold (to add a bit of glam to the piece)

Alcohol inks (see page 10) are an easy way to make a vibrant, abstract piece of art. YUPO paper (see page 9) works best with alcohol inks because it is nonabsorbent and water-repellent, which allows for the inks to dry in organic shapes while retaining their vivid colors.

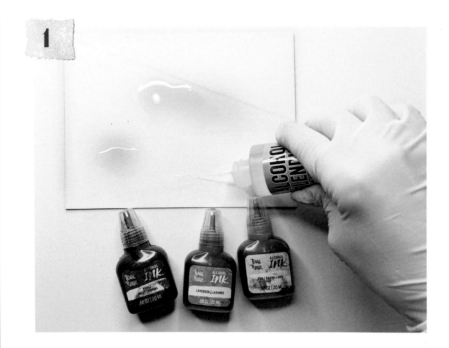

1

Pour 1 tablespoon (0.5 ounce, or 15 ml) of the isopropyl alcohol or blending solution into the spray bottle and set aside. Cover your workspace with the tarp, if not using the aluminum baking tray, and put on your rubber gloves. Lay the YUPO paper horizontally on your workspace. Pour a few drops of the alcohol onto the paper before adding any inks. This is what helps create cool shapes with the inks.

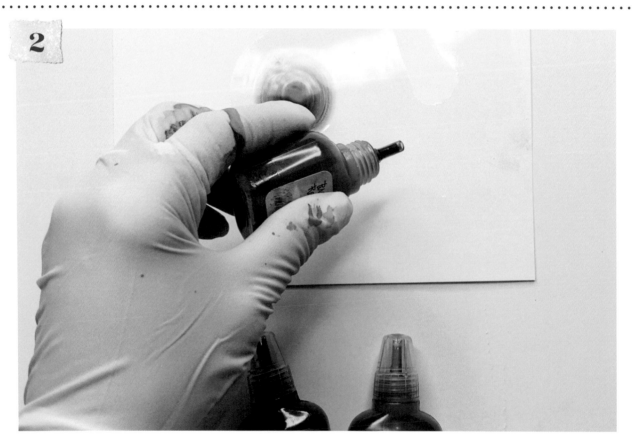

2

Start by opening the alcohol inks and squeezing a few drops of the first color onto the paper. We're only using three colors for this smaller project, but you can adjust the number of colors depending on the size of your paper. As you drip the first color, you will see the ink extend through the clear alcohol, making interesting waves. Add drops of the other colors, trying out different quantities. If the inks don't have a pouring tip, use a pipette to extract the color and drop it onto the paper with precision.

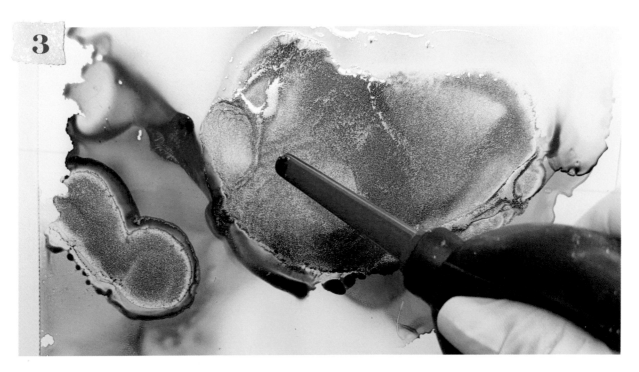

3

Alternate adding more drops of each color while blowing the alcohol with the straw or air blower. This will create interesting shapes and help certain areas dry faster, creating defined color clusters on the paper. Add the gold ink to your paper for a touch of gilded glam. Again, use the straw or air blower to shape the ink. Use the alcohol in the spray bottle to lighten the inks on the paper and help dry areas become wet and blendable again.

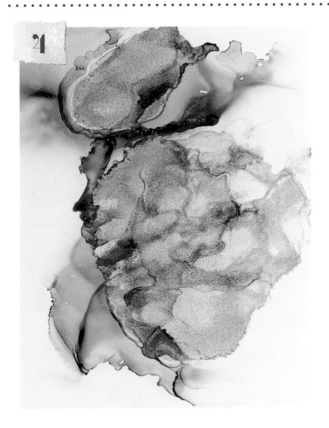

4

Let your artwork dry for at least 2 hours.

TIP

Alcohol inks behave differently depending on the brand, color, quantity poured, and even the temperature of the room. Experiment with color combinations and by creating different shapes with a blower or by just tilting the paper. Doing these things will give you a completely new piece of art every time.

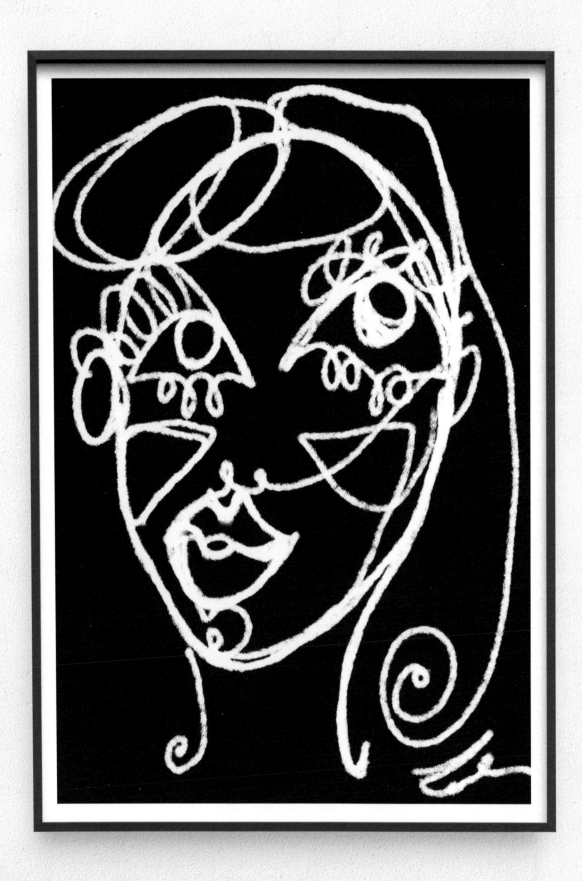

Single Line Portrait

MATERIALS

- ✓ 9 x 12-inch (23 x 30 cm) black mixed media paper
- ✓ Painter's tape (optional)
- ✓ Pencil
- ✓ White or gold paint pen

Inspired by Picasso's famous one-line drawings, this Cubist-like rendering of a portrait on black mixed media paper will add a pop of modern art to any room.

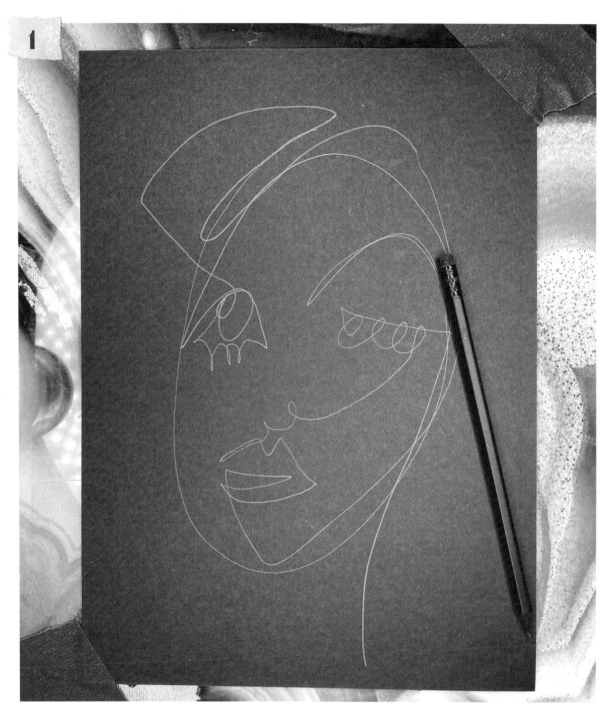

Lay your paper vertically on your prepared workspace and tape it down if you feel it slipping. Sketch the portrait with the pencil using the following guidelines:

- Regardless of where you start drawing on the paper, do not lift your pencil, creating a complete portrait in a single fluid line.

- Keep the line the same width.

- Try to avoid overlapping your pencil strokes too many times.

- Every time you add a detail that is usually represented with a line, substitute it with a loop (e.g., eyelashes should look like the cursive letter I).

- Avoid using an eraser unless you slip or want to edit a small segment.

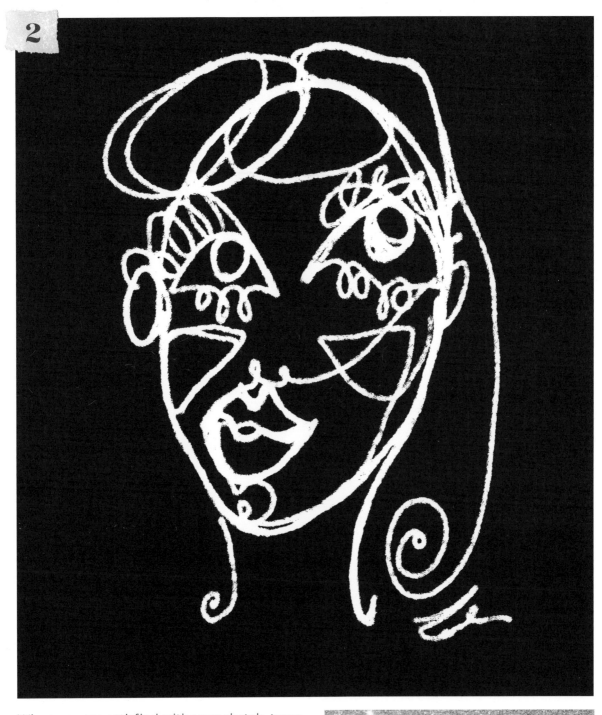

When you are satisfied with your sketch, trace over it with the paint pen in a fluid line. Sign your work of art!

TIP

You may want to practice a few portrait sketches on scrap paper before committing one to the black paper.

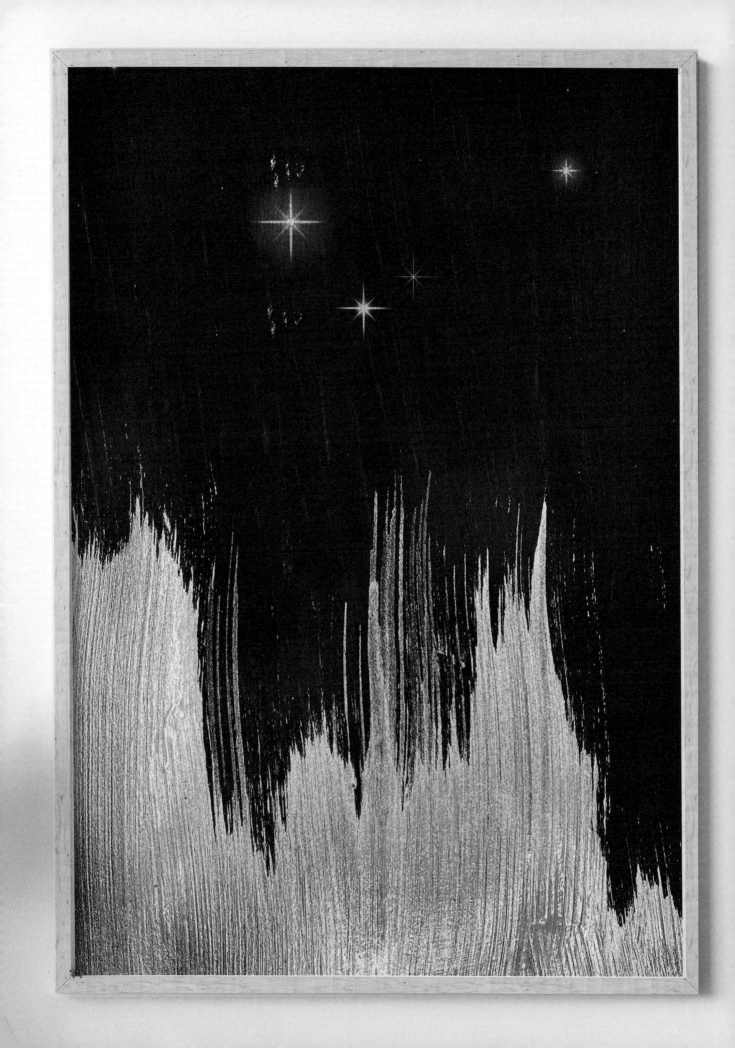

Golden Night Sky

MATERIALS

- ✓ 8 x 10-inch (20 x 25 cm) acrylic paper

- ✓ Painter's tape (optional)

- ✓ Highly pigmented dark navy blue acrylic paint (we used FolkArt Pure Artist Pigment in Prussian Blue)

- ✓ Palette (plastic or paper)

- ✓ 1½-inch (4 cm) flat hog bristle brush

- ✓ Cup filled with water (for cleaning the brush)

- ✓ Towel (for blotting/drying the brush)

- ✓ Metallic gold acrylic paint of your choice (we used DecoArt Americana Decor Metallics in Vintage Brass)

- ✓ #1 liner nylon brush

If you're not a morning person (see Rising Sun on page 33), then this is the artwork for you. The pop of gold on the dark navy background makes a gorgeous, decorative statement. To learn more about the various metallic gold acrylic paints, see page 14.

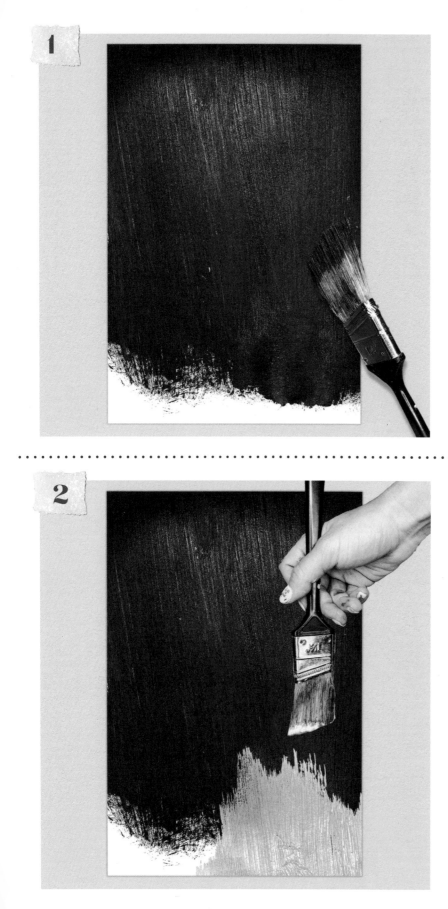

1

Lay your paper vertically on your prepared workspace and tape it down if you feel it slipping. Squeeze a walnut-size amount of the navy blue paint onto your palette. Dip the 1½-inch (4 cm) brush in the paint. Using vertical brushstrokes, cover the paper, leaving 1 to 2 inches (2.5 to 5 cm) bare at the bottom. Let it dry for 2 hours. Wash and dry your brush.

2

Squeeze a walnut-size amount of the metallic gold paint onto the palette and dip the tip of the clean, dry 1½-inch (4 cm) brush into it. Do not oversoak the brush, because you want the tail of the stroke to look dry and sparkly, leaving a textured trail that resembles stars. Cover the bottom half of the paper, using vertical strokes that move from the bottom of the paper up. Make sure these vary in height, like a mountain range. Apply a second layer of paint if there are any visible holes or you want to achieve a richer gold shade.

3

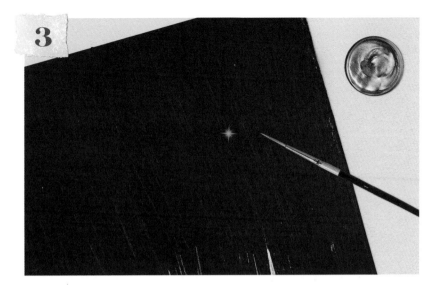

Using the #1 liner brush and the metallic gold paint, paint a star at the top right of the canvas. Start the star by painting a small cross, and then add two diagonal strokes for an eight-point star.

4

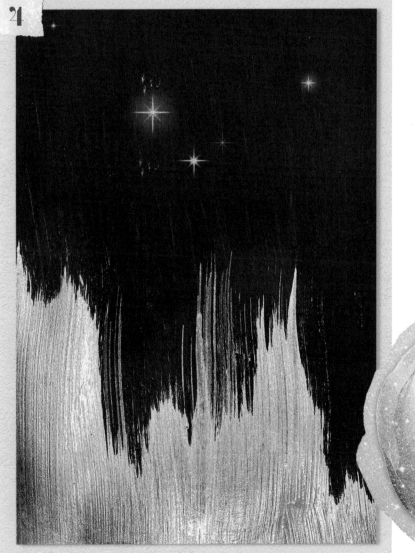

Continue adding eight-point stars, along with a group of three stars in varying sizes at the top center of the painting and a smaller star at the top left. If you want to add even more stars, alternate the larger eight-point stars with smaller diamonds and dots. Let your artwork dry for 3 hours.

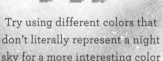

TIP

Try using different colors that don't literally represent a night sky for a more interesting color composition. The stars at the top of the painting can be included or excluded.

17

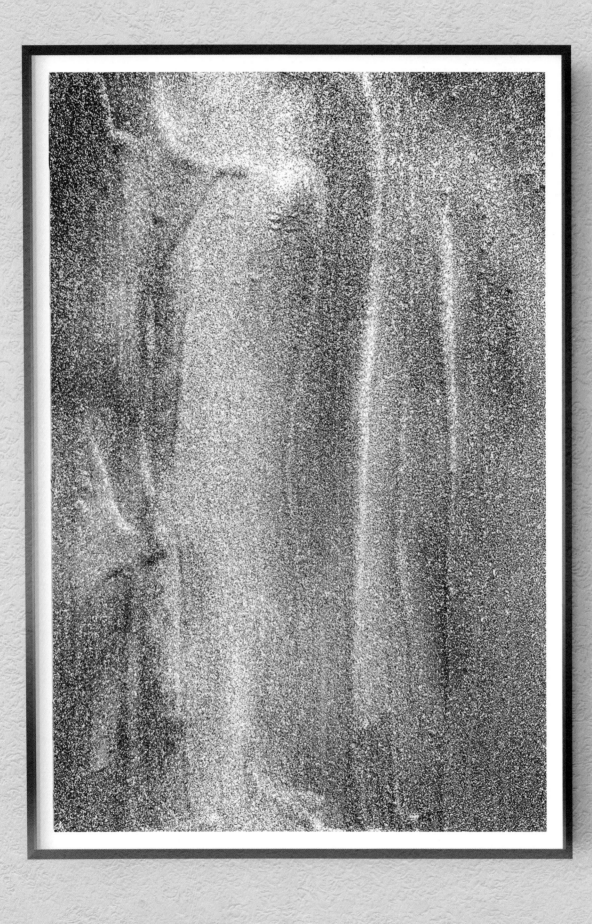

Glitter Ombre

MATERIALS

- Tarp, plastic tablecloth, or plastic wrap (to cover your workspace)

- 8 x 10-inch (20 x 25 cm) canvas paper

- 1½-inch (4 cm) flat hog bristle brush

- Mod Podge or Elmer's Clear Glue

- Extra-fine (0.4 mm) glitter in 3 colors of your choice (we used Feldspar, Florentine Gold, and Sterling from Martha Stewart Crafts Assorted Fine Glitter 24 Pack)

- Shoebox lid or plastic cup (to capture excess glitter)

This glitzy, glam, abstract piece can work on its own or as a background for a photo or print. The possibilities for different color combinations are endless. To learn more about glitter, see page 18.

TIP

You can also add extra glitter colors to make your piece even more interesting and colorful.

1

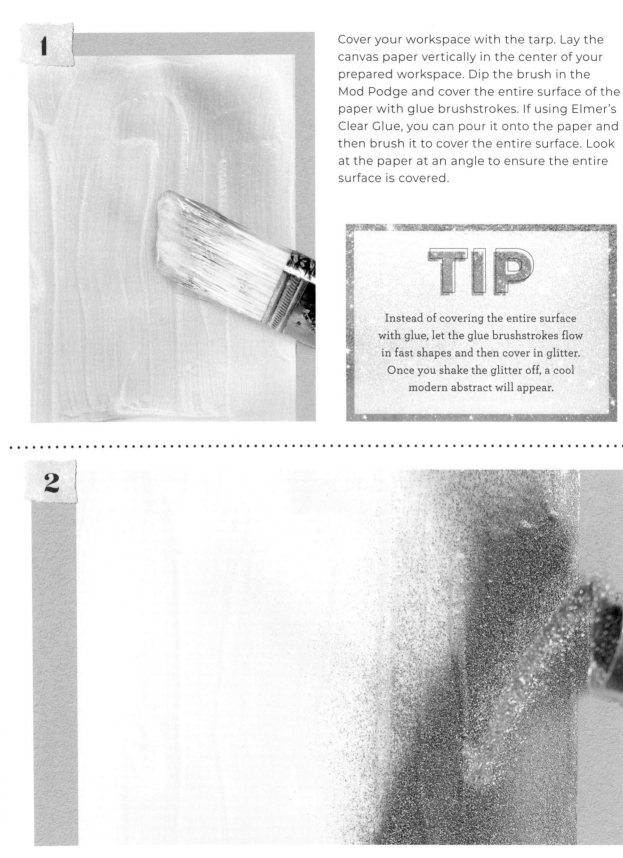

Cover your workspace with the tarp. Lay the canvas paper vertically in the center of your prepared workspace. Dip the brush in the Mod Podge and cover the entire surface of the paper with glue brushstrokes. If using Elmer's Clear Glue, you can pour it onto the paper and then brush it to cover the entire surface. Look at the paper at an angle to ensure the entire surface is covered.

TIP

Instead of covering the entire surface with glue, let the glue brushstrokes flow in fast shapes and then cover in glitter. Once you shake the glitter off, a cool modern abstract will appear.

2

Take the first glitter color and pour the glitter in vertical movements, ensuring that the right half of the paper is completely covered.

3

Continue covering the next quarter of the paper with the second glitter color in the same way as in step 2, slightly overlapping the left edge of the first glitter color. Using the third glitter color, completely cover the remaining quarter of the paper, slightly overlapping the second glitter color.

4

Let your artwork dry for at least 3 hours. Once dry, carefully lift the paper by its edges and shake it vigorously over the shoebox lid. Tap the sides of the paper on a hard surface for all the glitter that isn't sticking to shed.

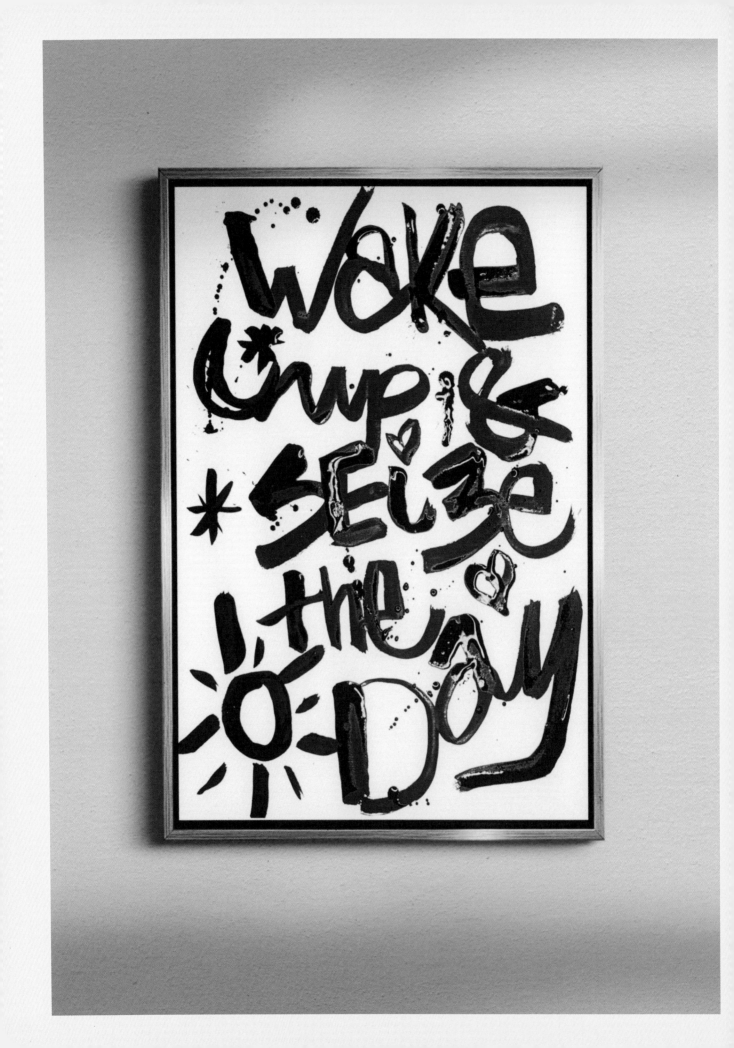

Motivational Lettering

MATERIALS

✓ 8 x 10-inch (20 x 25 cm) paper

✓ Pencil

✓ Transparent ruler

✓ Acrylic ink or high flow acrylic (we used Daler-Rowney FW Acrylic Ink in Black)

✓ Plastic cup

✓ #7 round nylon brush

✓ Eraser

Motivate yourself in a fun and expressive way with this simple project. Just choose a favorite saying or quote, write it with some acrylic ink and a paintbrush, and finish with some energetic ink splatters. To learn more about acrylic ink and high flow acrylic, see page 10.

1

cap height _____

x-height ---------------------------

baseline _____

Lay your paper vertically on your prepared workspace. Using your pencil and ruler, lightly draw five groups of guidelines (or the number of lines for your saying), as shown in the image (they don't need to be as detailed as in the image). Each guideline has a top line (cap height), a middle line (x-height), and a bottom line (baseline). Make the space between the cap height and baseline 1 inch (2.5 cm) and the space above the cap height ¾ inch (2 cm). The baseline is the writing line, the x-height marks the height of lowercase letters, and the cap height marks the height of uppercase letters, though they can extend into the space above this line. We loosely follow these guidelines, but they can help you keep your text straight when writing your words with the brush and ink.

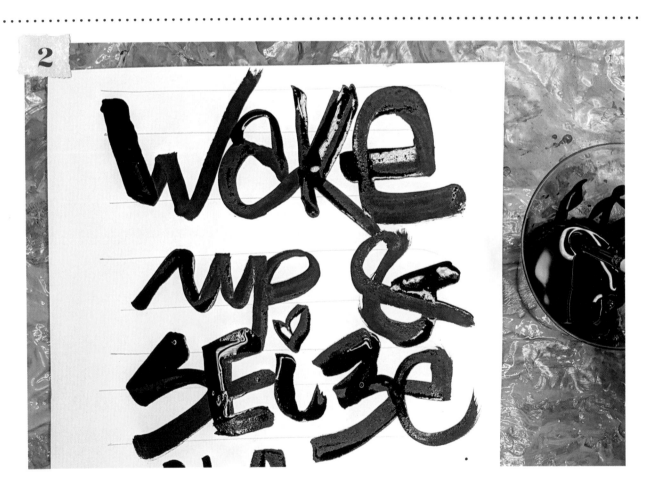

2

Pour a small amount of the ink into a plastic cup. You may want to practice writing your saying on some scrap paper with the brush and ink before committing it to the art paper. When writing your saying, alternate between using capital and lowercase letters, and print and cursive styles. Try to write in a fluid motion without much interruption. Use the pencil lines as guides for the bases of your letters.

3

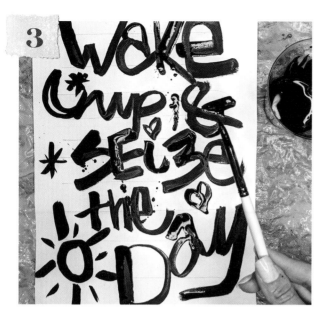

Fill in blank spaces with simple design elements, like the stars, hearts, and sunshine we drew here. Start adding some ink splatters. Hold the brush between your thumb and index, dip the tip of the brush in the ink, and then let the ink drip over a certain area or vigorously shake the brush in one swift motion and direction, like an orchestra conductor.

4

Continue adding ink splatters. Let your artwork dry for 3 hours.

TIP

Have fun experimenting with different acrylic ink colors for the text, or use a few different colors of ink splatters for a 1980s vibe.

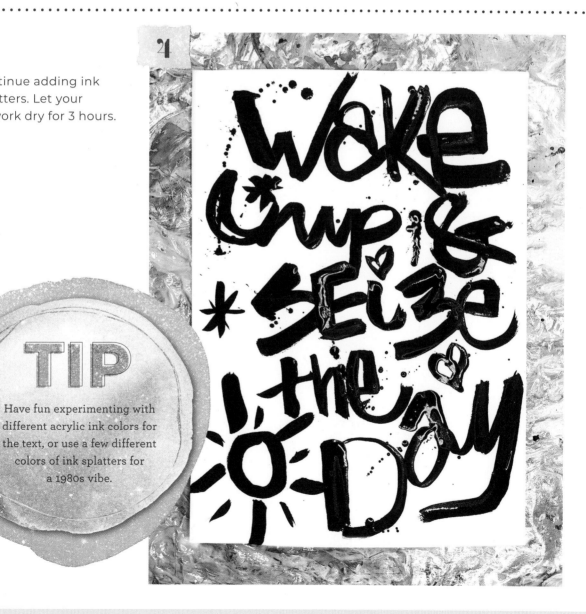

Color Palette Stripes

MATERIALS

✓ 6+ colors of acrylic paint (equal number of light and dark colors)

✓ Palette (plastic or paper)

✓ 9 x 12-inch (23 x 30 cm) canvas or acrylic paper

✓ Painter's tape (optional)

✓ #10 and #6 (optional) flat nylon brushes

✓ 2 cups filled with water (for cleaning the brushes)

✓ Towel (for blotting/drying the brush)

This painting is a fun way to play with your favorite color palettes while adding accent colors to a room. For this project, we were inspired by The Hamptons palette on page 25 for its beachy vibe.

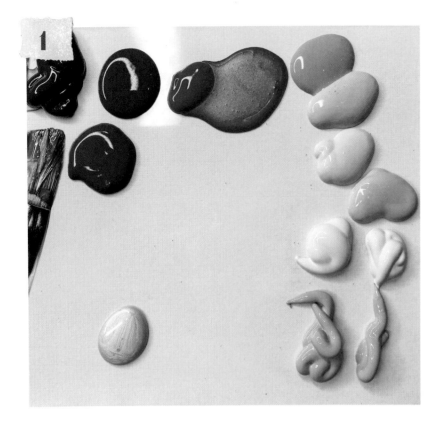

After choosing your acrylic paint colors, squeeze a dab of each color, no more than a quarter-size each, onto your palette. That should be enough to paint one stripe with each color. We used twelve different blues and mixed two more, for a total of fourteen (FolkArt Multi-Surface Metallic Acrylic Paint in Sapphire and Platinum, and Americana Acrylic Paint in True Blue, Primary Blue, Sea Glass, Baby Blue, Blue Chiffon, Salem Blue, Victorian Blue, Sky Mist, Ocean View, and Skyline).

Lay your paper horizontally on your prepared workspace and tape it down if you feel it slipping. Dip the #10 brush into one of the lighter colors, and starting 1 to 1½ inches (2.5 to 4 cm) from the top or the bottom, drag the paint in a consistent manner, painting a stripe. This may take some getting used to because you may have no paint left on the brush when you reach the end of the stripe. Try not to drag the stripe all the way to the edge, leaving about 1 to 1½ inches (2.5 to 4 cm) of white space.

3

Move on to your next color and paint the stripe the same way you did in step 2, slightly overlapping the previous stripe. Whenever changing the paint color, ensure that you first clean the brush in water and blot it dry, so the color will be opaque when applied.

4

Continue painting stripes, arranging the colors to create a contrasting palette, varying the lengths of the stripes, and making sure to clean the brush in between colors. You can also alternate painting stripes with the #6 brush to vary the width of some of and to even go over some already-painted stripes. Let your artwork dry for at least 2 hours.

TIP

Add an interesting highlight by painting one of the stripes with a metallic color after the initial painting has dried.

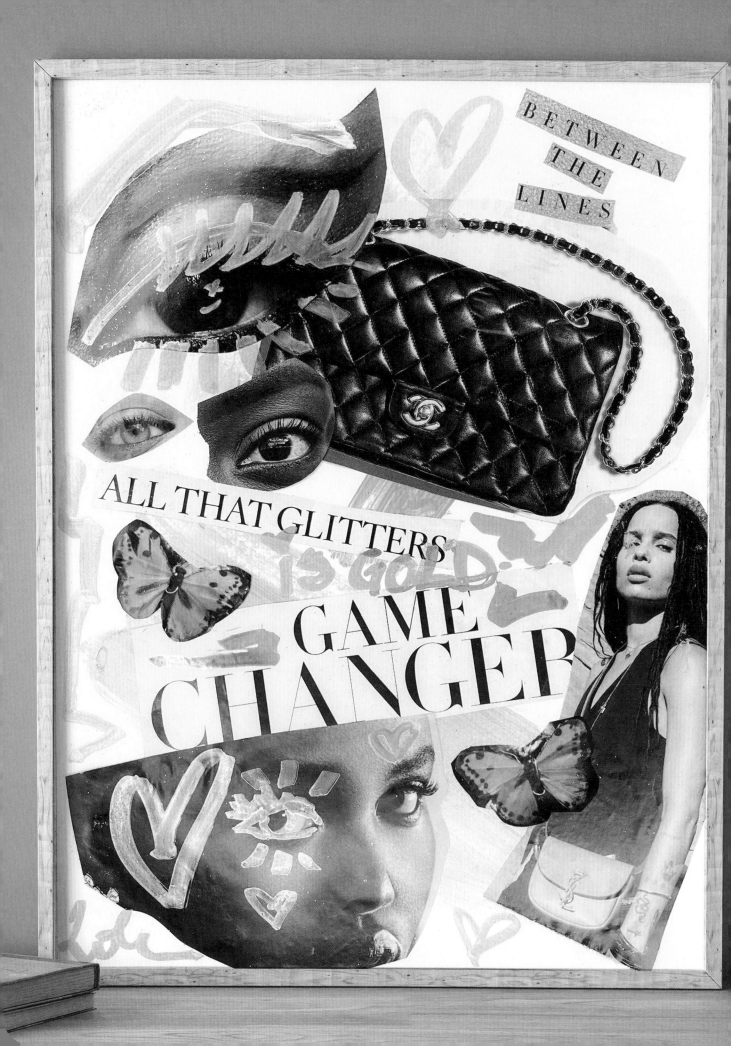

Fashion Collage

MATERIALS

- ✓ Scissors
- ✓ Fashion magazines
- ✓ 9 x 12-inch (23 x 30 cm) mixed media paper
- ✓ Metallic gold acrylic paint of your choice (we used Golden Fluid Acrylic in Iridescent Gold Deep)
- ✓ Palette (plastic or paper)
- ✓ #9 flat nylon brush
- ✓ Elmer's Clear School Glue stick
- ✓ Metallic gold paint pen

A fashion collage is a fun and easy way to create something decorative while upcycling magazines. Look for bold images and words and/or quotes that stand out to you and match your color palette and design style.

Cut out images and text from the fashion magazines. Set aside.

Lay your paper vertically on your prepared workspace. Squeeze a penny-size dab of metallic gold paint onto your palette. Dip your brush into the paint and paint abstract lines on the paper to create a background for your collage. Use more paint if needed. Let it dry for 15 minutes.

Select the magazine cutouts you want to use and strategically place them at the side of your paper to plan the layout. Don't overthink this part; the idea of collage is that it is created as you go and is not so planned. Apply glue to the back of your first cutout and place it on the paper as an anchor piece.

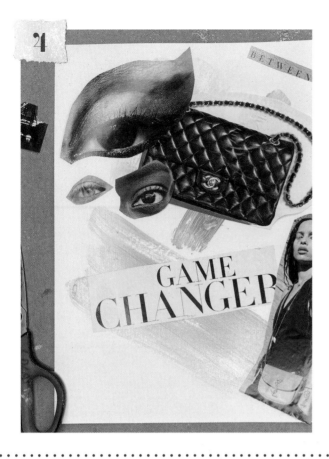

4

Continue building your collage, layering and gluing your magazine cutouts.

TIP

We recommend placing images of objects as a first layer of your collage and words and quotes as a second layer.

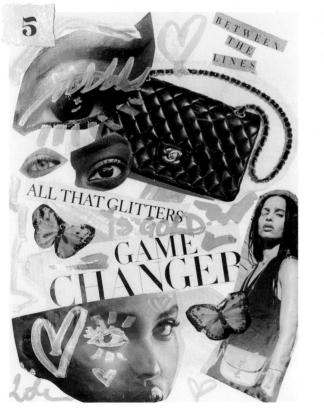

5

When you are satisfied with the layout, use the metallic gold paint pen to add accents, outlines, and text on the images and to fill in any glaring white space.

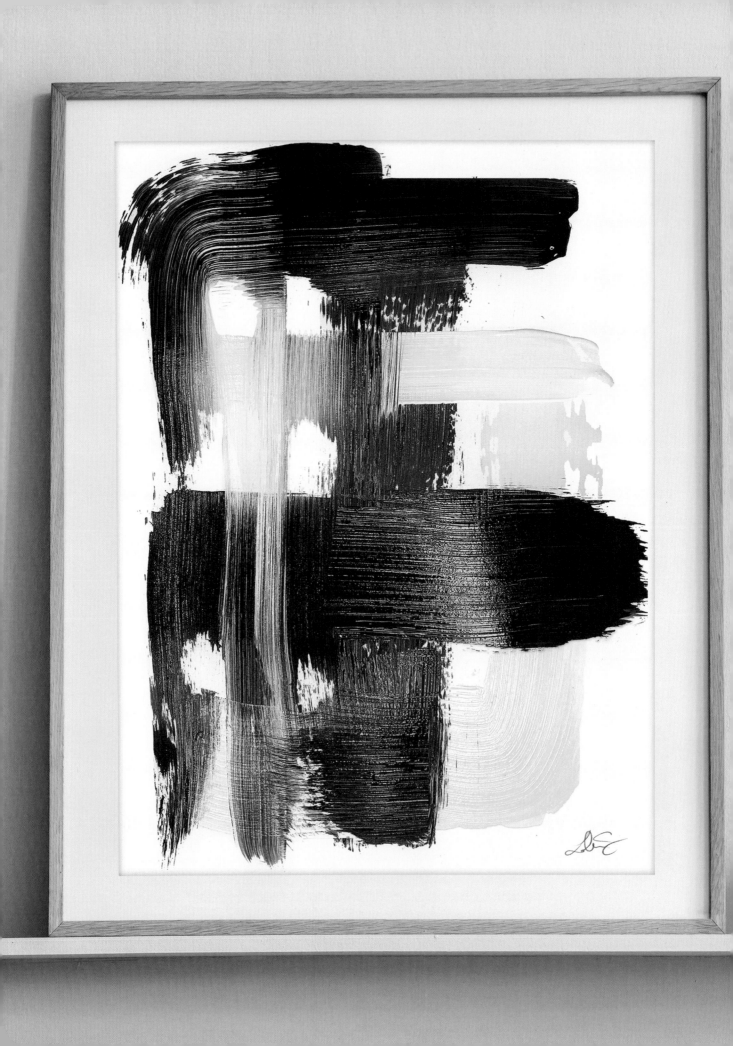

Elevated Abstract

MATERIALS

- ✓ 9 x 12-inch (23 x 30 cm) canvas or acrylic paper

- ✓ Painter's tape (optional)

- ✓ 6 colors of acrylic paint (3 light colors and 3 dark colors)

- ✓ Palette (plastic or paper)

- ✓ Two 1½-inch (4 cm) flat hog bristle brushes

- ✓ 2 cups filled with water (for cleaning the brushes)

- ✓ Towel (for blotting/drying the brushes)

- ✓ 1-inch (2.5 cm) flat hog bristle brush (optional)

Create your own abstract masterpiece to elevate the look of any room in a few easy steps. All you need is a color palette of six acrylic paint colors, with three of them being light and three of them being dark. For this project, we were inspired by the Coastal Chic palette on page 24.

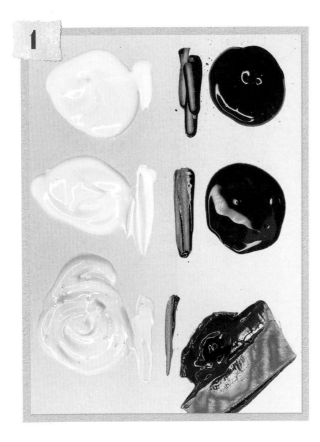

1

Lay your paper vertically on your prepared workspace and tape it down if you feel it slipping. Squeeze a quarter-size dollop of each of your acrylic paints onto your palette. We used DecoArt Americana Acrylic Paints in Light Buttermilk, Snow (Titanium) White, Natural Buff, and Navy Blue, and Golden Fluid Acrylics in Prussian Blue Hue and Anthraquinone Blue.

Dip the tip of one of your 1½-inch (4 cm) brushes into one of the lighter colors and create a reverse L-shape stroke on the bottom half of the paper. Using the second 1½-inch (4 cm) brush, dip the tip into one of the dark colors and paint a vertical stroke up the center of the paper. Dip the brush's tip in one of the cups of water, swirl it around a couple of times, and then pat it dry with the towel.

2

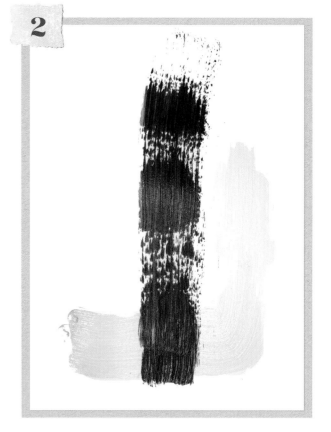

3

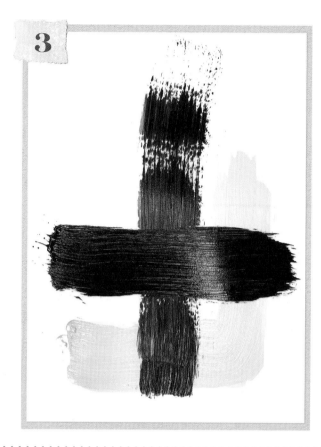

Dip the tip of your just-cleaned brush into another dark color and make a horizontal stroke across the center of the paper. Dip the brush's tip in the cup of water for your dark colors, swirl it around a couple of times, and then pat dry with a towel.

TIP

If you have paint left on your palette, do not discard it. Use it to make a "matching" abstract piece with different strokes but the same colors.

Continue adding both light and dark paint strokes, overlapping the already-painted lines. Clean your brush for the dark colors in between uses, but keep the brush for the light colors "dirty." Doing this will create interesting mixed textures when you dip your brush into the different light colors. To add a little more visual interest, use the 1-inch (2.5 cm) flat hog bristle brush for some of the brushstrokes. Leave some white space in between the strokes so the painting is not too overpowering. Let your artwork dry for at least 3 hours. Once your painting is completely dry, you can leave as is, or you can add more brushstrokes with the same paint colors or a metallic color for a final accent, as straight lines or even paint splatters.

4

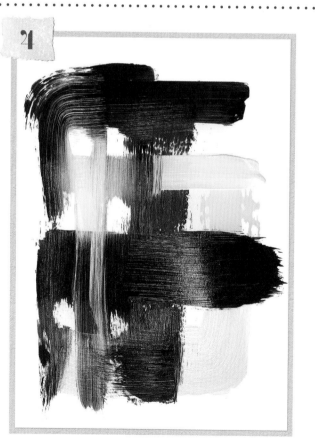

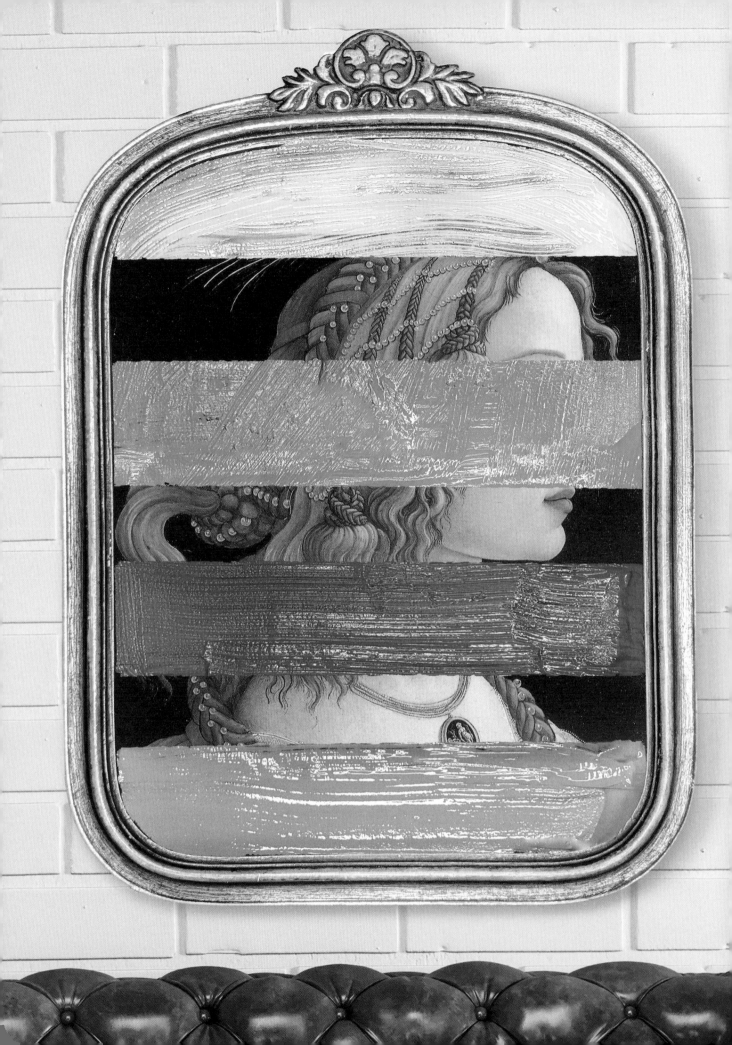

Modern Vintage

MATERIALS

- ✓ Artwork to repurpose

- ✓ Painter's tape

- ✓ 4 colors of acrylic paint (we used Liquitex Basics Acrylic in Bright Aqua Green, Primary Yellow, Fluorescent Pink, and Vivid Red Orange)

- ✓ Palette (plastic or paper)

- ✓ 1-inch (2.5 cm) or 1½-inch (4 cm) flat hog bristle brush

- ✓ Cup filled with water (for cleaning the brush)

- ✓ Towel (for blotting/drying the brush)

This is a fun way to repurpose an inexpensive thrift-store find into a contemporary work of art. Look for an artwork in an interesting frame, and then all you will need to do is add a bold, colorful design and hang it on your wall.

1

Find the piece you want to repurpose. We found this vintage work of art, with a printed reproduction of a Botticelli painting, on eBay. We like pieces that have antique frames!

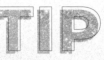

TIP

If you like the frame but not the artwork in it, lay down a base of black acrylic paint with a 2-inch (5 cm) flat hog bristle brush, entirely covering the old art. Let the paint completely dry, then add a colorful design. We suggest try painting a lightning bolt across it!

2

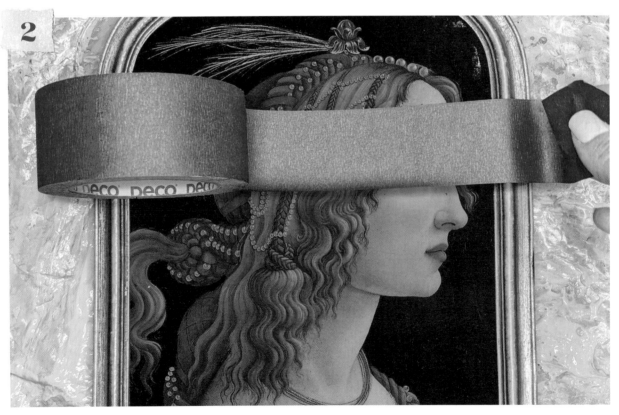

Set your vintage piece on your prepared workspace. Create a design with painter's tape. Here, we covered areas of the artwork to create 2-inch-wide (5 cm) stripes. Cover parts of the frame or the entire frame with painter's tape, if necessary, to protect it.

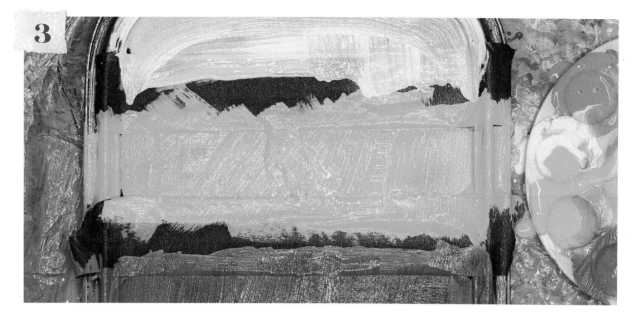

3

Pour the paint colors on your palette. The amount will depend on the size of the surface to be covered. Start by pouring 1 tablespoon (15 ml) and add more as needed. It is better to use less paint, as acrylics dry fast. Using the brush, start covering the open areas. Wash and dry the brush when you change colors. Let the paint dry for at least 30 minutes, and then apply a second and even a third layer of acrylic paint until the color looks rich and opaque.

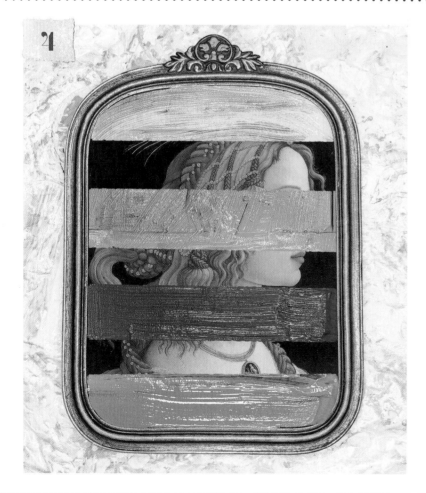

4

Let the artwork dry for 6 hours. Once the paint is completely dry, carefully remove the painter's tape. Try your next piece using the same technique and painting a lightning bolt across it.

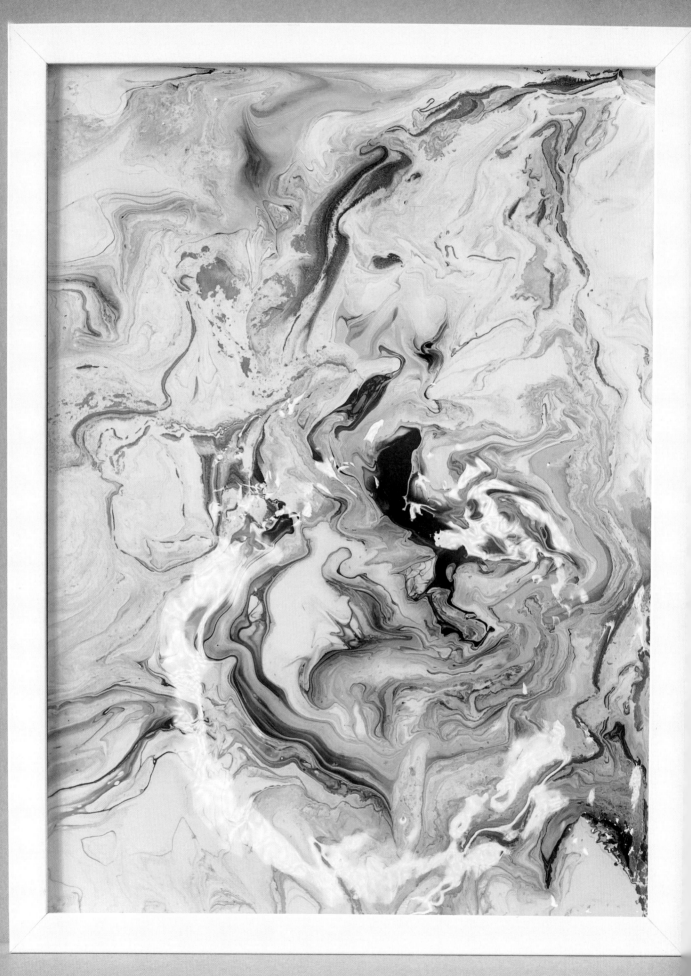

Marble Pouring

MATERIALS

✓ Tarp, plastic tablecloth, or plastic wrap (to cover your workspace)

✓ Rubber gloves (to protect your hands)

✓ Two or three 9-ounce (265 ml) short plastic cups (to elevate the paper)

✓ Mixed media paper

✓ White acrylic pouring paint (we used Arteza Pouring Acrylic Colors in Titanium White)

✓ Wooden mixing stick or disposable plastic knife

✓ Scissors

✓ 8-ounce (240 ml) plastic mixing cup

✓ 4 acrylic pouring paint colors (we used Arteza Pouring Acrylic Colors in Titanium White, Phthalo Green, Forest Green, and Sea Green)

✓ Metallic gold acrylic pouring paint (we used Arteza Acrylic Pouring Paint in Gold)

Some of the most beautiful abstract art pieces are created by marbling. Fortunately, there are pouring acrylics (see page 11) that help make this process easier than it looks, but you don't need to tell that to your impressed family and friends.

1

Cover your workspace with the tarp and put on your rubber gloves. Invert the plastic cups and place your paper on top of them horizontally. This way the paper is "floating," and the paint can drip over the sides, preventing the paper from getting stuck to the table once dried.

TIP

If you don't have pouring paint, you can use regular acrylic paint mixed with a marbling or pouring medium. We use Martha Stewart Crafts Multi-Surface Marbling Medium. Follow the instructions on the label and you've turned your paint into a marbling-ready paint.

2

Start by squeezing 3 tablespoons (45 ml) of the white pouring paint onto the paper and spread it over the entire surface of the paper using the wooden stick.

Cut a 2-inch (5 cm) cylinder from the plastic mixing cup that is open at both ends. This gives this technique the name "open-cup pour."

· ·

4

Place the cylinder in the center of your paper, over the wet white paint, and fill it with the paint colors. Squeeze each color into the center of the cylinder, about 1 tablespoon (15 ml) of each.

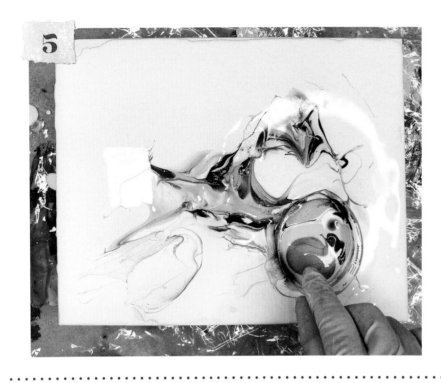

5

Add the metallic gold paint last. Lift the cylinder off the paper and set aside.

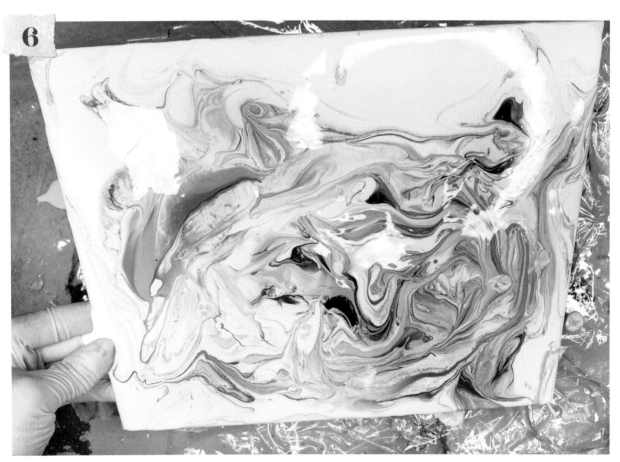

6

Grab the paper delicately at the corners and start tilting the paint. You will see the lines generate from gravity. Try pulling the paint all the way to the edges and then tilt it in the opposite direction.

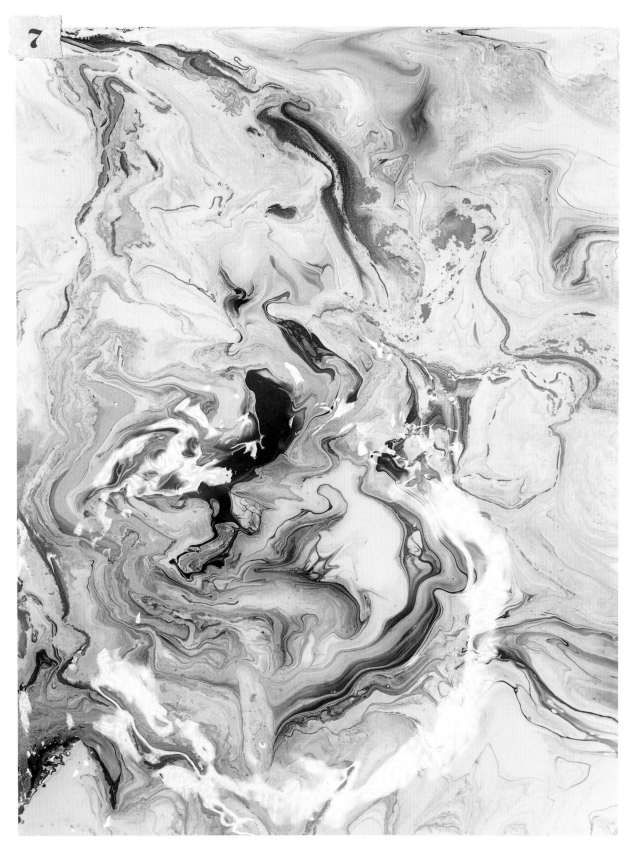

When you are satisfied with the marbling you've created, lay the artwork on the inverted plastic cups and let it dry overnight.

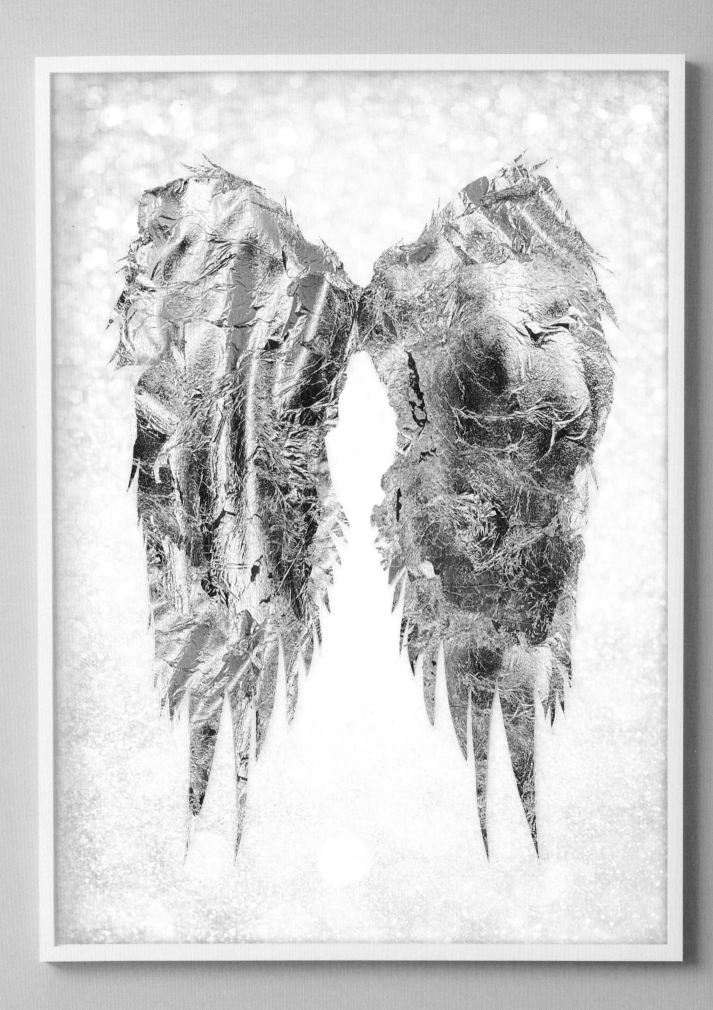

Gold Leaf Wings

Embellish these wings with gold leaf to give them a heavenly look. To learn more about gold leaf, see page 18.

MATERIALS

- ✓ Tarp, plastic tablecloth, or plastic wrap (to cover your workspace)

- ✓ Mod Podge

- ✓ Plastic cup

- ✓ #4 and #5 flat nylon brushes

- ✓ Wings template (page 137)

- ✓ Imitation gold leaf sheets (they usually come in 5½-inch [14 cm] square sheets; you will need at least 4 for this project)

- ✓ Shoebox lid or plastic cup (to capture excess gold leaf flakes)

- ✓ Speedball Mona Lisa Metal Leaf Sealer (optional)

TIP

Gold leaf is easier applied with cotton gloves, but they are not necessary, and your gilded hands after finishing this project will make for a great picture! Don't worry. It washes off with water and dish soap.

1

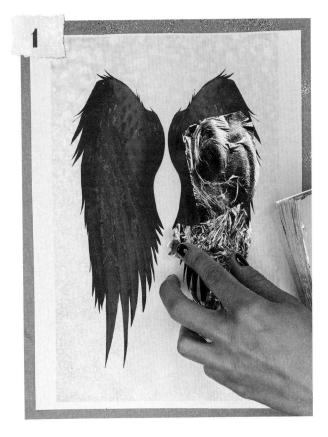

Cover your workspace with the tarp. Lay the template on your prepared workspace. Pour enough Mod Podge into the plastic cup to cover the wings. Using the #4 brush, apply the Mod Podge to the template, entirely covering only one of the wings. Once the glue is applied, touch the paper with your pinky finger every 30 seconds. When it feels sticky to the touch, you are ready to apply the gold leaf. It is important not to lay the gold leaf when the glue is still wet; you want the glue to feel tacky. Make sure your hands are clean and dry. Open the package of imitation gold leaf and carefully lift the tissue paper that protects each leaf. The sheets are very delicate, so do not pull or yank them. If a sheet breaks, it can still be used. Do not despair! Cover the tacky glue with gold sheets, overlapping each gold piece by ¼ inch (6 mm) to avoid any black spaces.

2

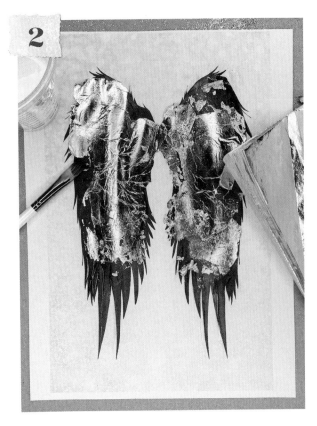

Repeat step 1 with the remaining wing. Let the gold leaf completely dry for at least a couple of hours, and then use the #5 brush to carefully smooth wrinkles and remove any extra gold leaf flakes. Lift the paper and shake off any excess gold leaf flakes over the shoebox lid.

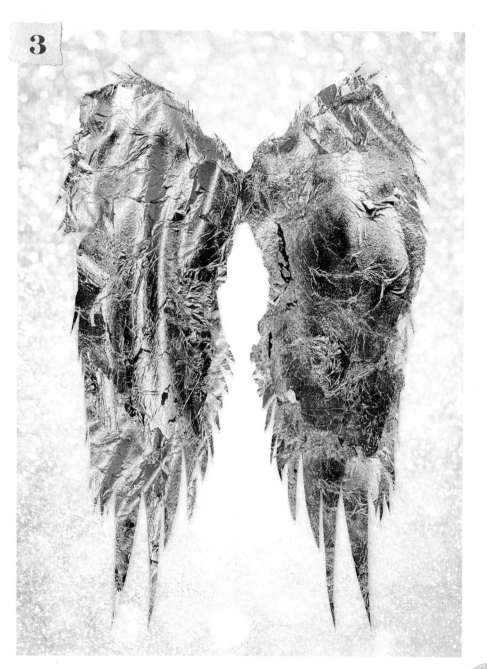

If you are planning on displaying this without protection, we recommend using the Mona Lisa Metal Leaf Sealer.

TIP

You can apply gold leaf to virtually anything. Try it on a flat, white porcelain dish!

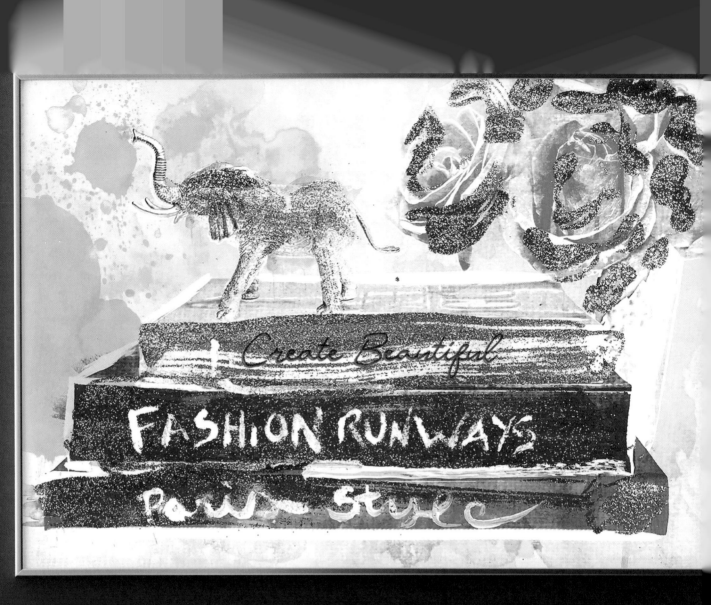

Create Beautiful

FASHION RUNWAYS

Paris Style

Glitter Still Life

MATERIALS

✓ Tarp, plastic tablecloth, or plastic wrap (to cover your workspace)

✓ Mod Podge

✓ Plastic cup

✓ #7 flat nylon brush

✓ Still Life template (page 139)

✓ Extra-fine (0.4 mm) glitter in 6 colors to match the artwork (we used aqua, gold, fuchsia, light pink, green, and dark blue)

✓ Shoebox lid or plastic cup (to capture excess glitter)

✓ Acrylic paint colors of your choice

✓ Palette (plastic or paper)

✓ #1 liner nylon brush

This Oliver Gal still life will come alive when you embellish it with six colors of glitter, taking it to the next sparkly level. To learn more about glitter, see page 18.

1

Cover your workspace with the tarp. Lay the template on your prepared workspace. Pour 1 ounce (30 ml) of Mod Podge into a plastic cup. Using the brush, apply the Mod Podge to the book spines on the template in thin brushstrokes. Let the glue dry until it is tacky, then sprinkle and cover with the desired glitter colors. Wait at least 30 seconds, then hold the paper over the shoebox lid and tap it to remove excess glitter.

2

Apply the Mod Podge to the elephant and flower. Try not to fully cover the flower with the glue, but apply accent strokes, both thick and thin, on the edges. Let the glue dry until it is tacky, then sprinkle and cover with the desired glitter colors. Wait at least 30 seconds, then hold the paper over the shoebox lid and tap it to remove excess glitter.

TIP

With practice, you'll learn which parts of an image look best when glittered. You can apply each of the glitter colors in separate steps or apply them all at the same time, being extremely careful to sprinkle the glitter color over the area it corresponds to.

3

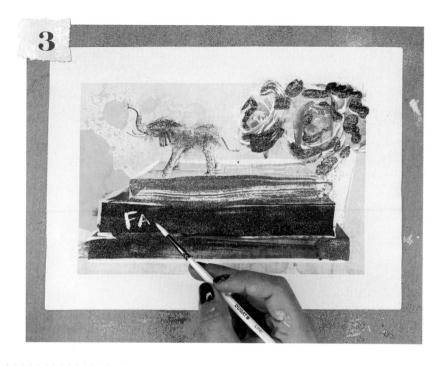

Let it dry for at least 2 hours. Place penny-size dabs of the acrylic paint on your palette. Use the #1 liner brush to write the book titles on the spines, cleaning and drying the brush between colors.

4

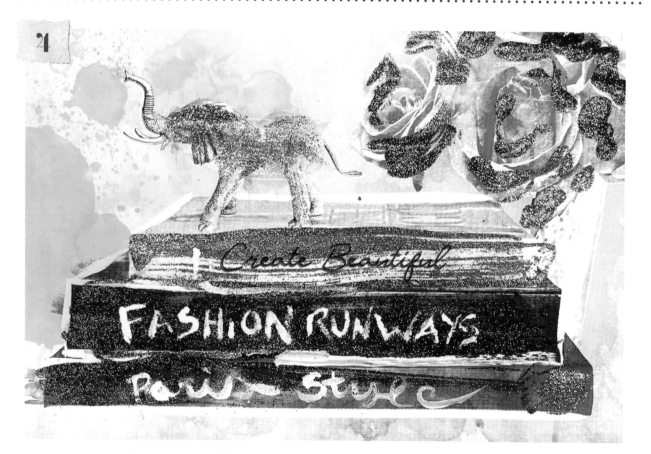

Let the artwork dry overnight. Shake and tap it a few more times over the shoebox lid to shed any loose glitter.

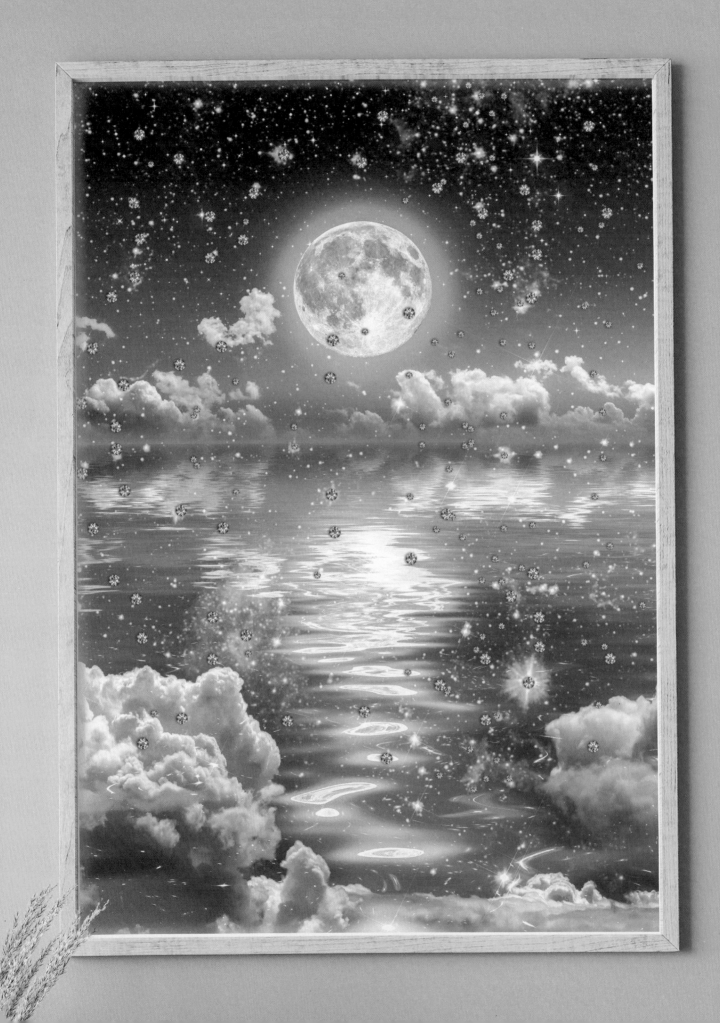

Rhinestone Moonlight

MATERIALS

- ✓ Candle and match or lighter
- ✓ Toothpick or chopstick
- ✓ #7 round nylon brush
- ✓ E6000 clear adhesive or hot glue gun
- ✓ Moonlight template (page 141)
- ✓ Copper rhinestones in an assorted-sizes pack

When you really want to make an artwork extra glam, rhinestones are your go-to embellishment. To learn more about rhinestones, see page 19.

Lay your template on your prepared workspace. Create a rhinestone pick tool by lighting a candle and dipping the tip of the toothpick into the wax. Let it cool. Mold the wax into a little ball tip on the toothpick. This will help you pick up the rhinestones and set them on the template.

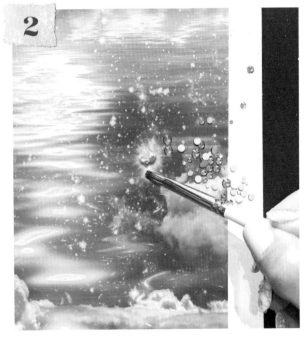

Using the brush, apply the adhesive to the areas of the template that look like stars. Do not apply too much adhesive.

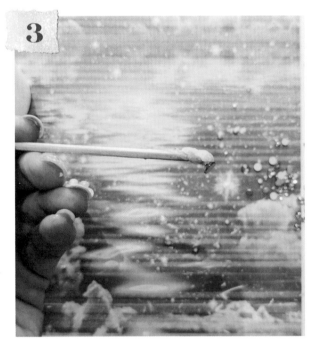

Select a rhinestone and lift it with your new pick tool. Place it on the adhesive on the template and hold down for 5 seconds. Lift, pick, and repeat.

4

Let the artwork dry for 6 hours, and then gently shake and reattach any rhinestones that are loose or fall off.

TIP

Use rhinestones of different sizes and colors to create the illusion of shining stars.

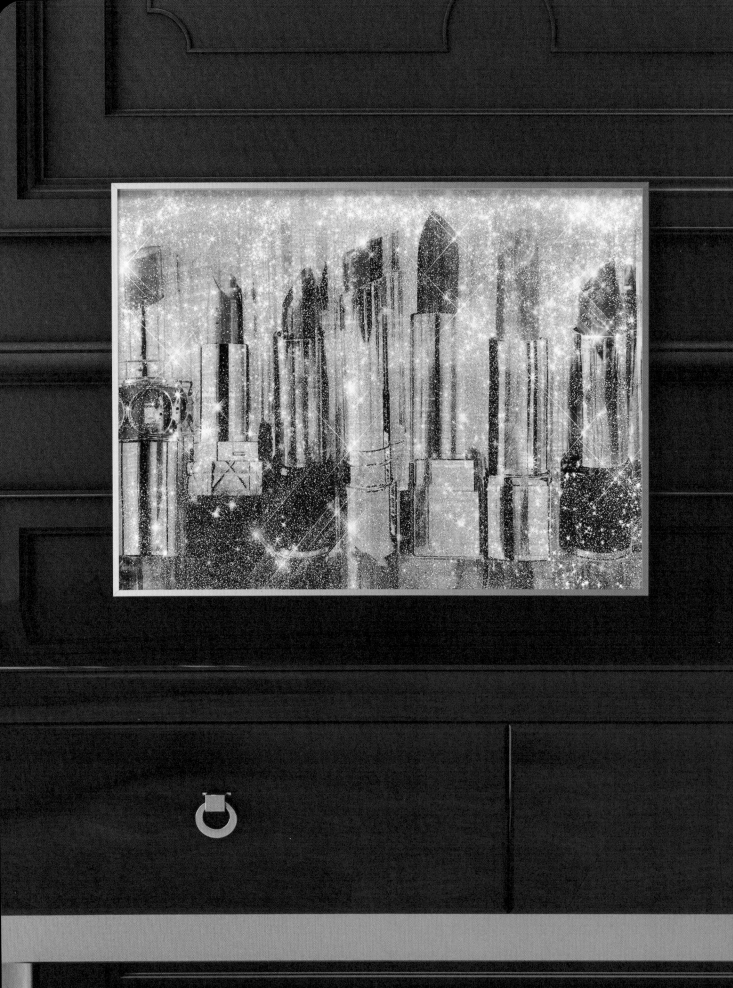

Diamond Dust Lipsticks

MATERIALS

- ✓ Tarp, plastic tablecloth, or plastic wrap (to cover your workspace)
- ✓ Mod Podge
- ✓ Plastic cup
- ✓ 1½-inch (4 cm) flat hog bristle brush
- ✓ Lipsticks template (page 143)
- ✓ Diamond dust or extra-fine (0.4 mm) transparent glitter
- ✓ Shoebox lid or plastic cup (to capture excess diamond dust)

Add some extra sparkle to this iconic Oliver Gal artwork with diamond dust. To learn more about diamond dust, see page 18.

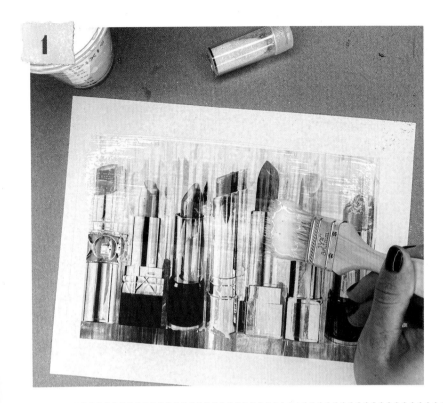

1

Lay your template on your prepared workspace. Pour 1 ounce (30 ml) of Mod Podge into the plastic cup. Using the brush, apply the Mod Podge to the template, entirely covering the image with wide, even strokes. Make sure everything is covered, then let the glue dry until it is tacky.

2

TIP

Substitute the diamond dust with extra-fine holographic or iridescent white glitter to create a more dramatic effect.

Quickly sprinkle the diamond dust all over the glue-covered area and let it sit for a couple of minutes.

3

Lift the paper and vigorously shake off any excess diamond dust over the shoebox lid.

4

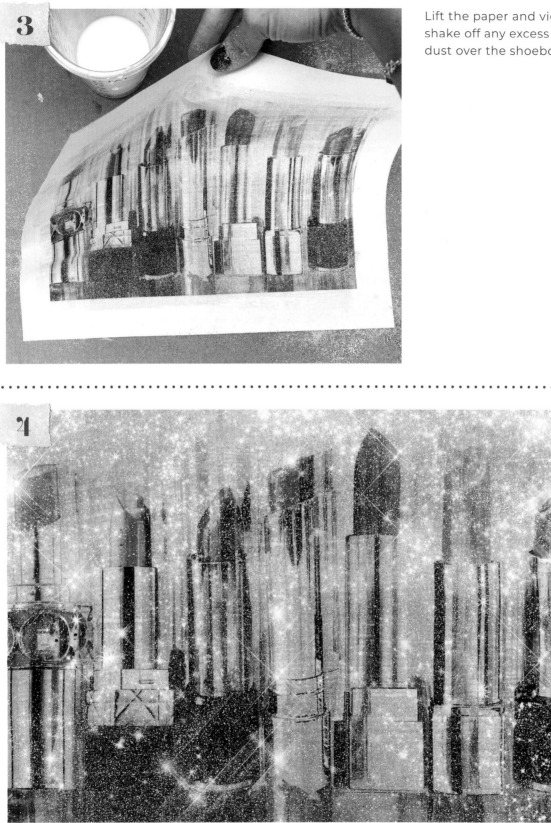

Let the artwork dry for 2 hours. Shake and tap it a few more times over the shoebox lid to remove any remaining loose diamond dust.

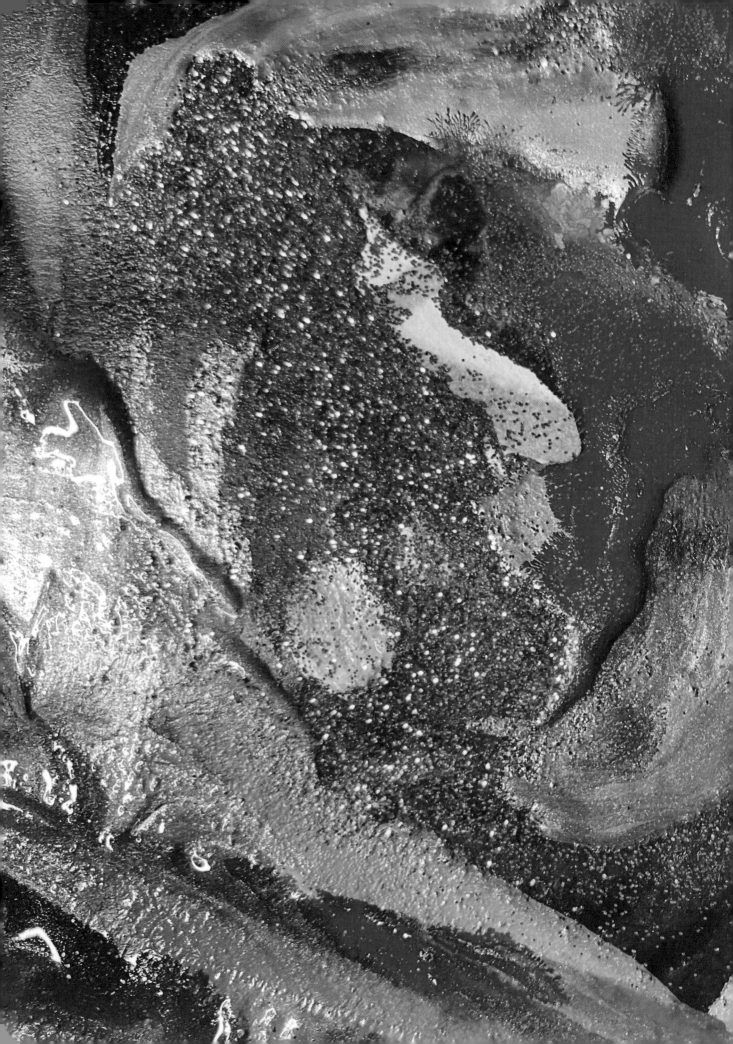

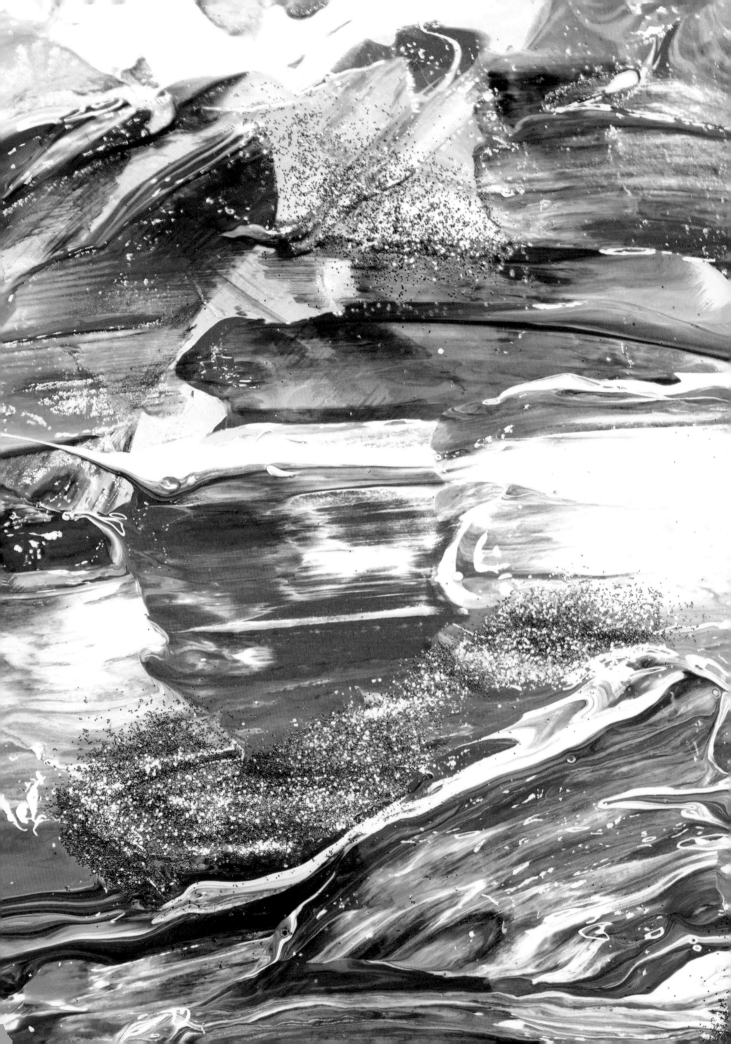

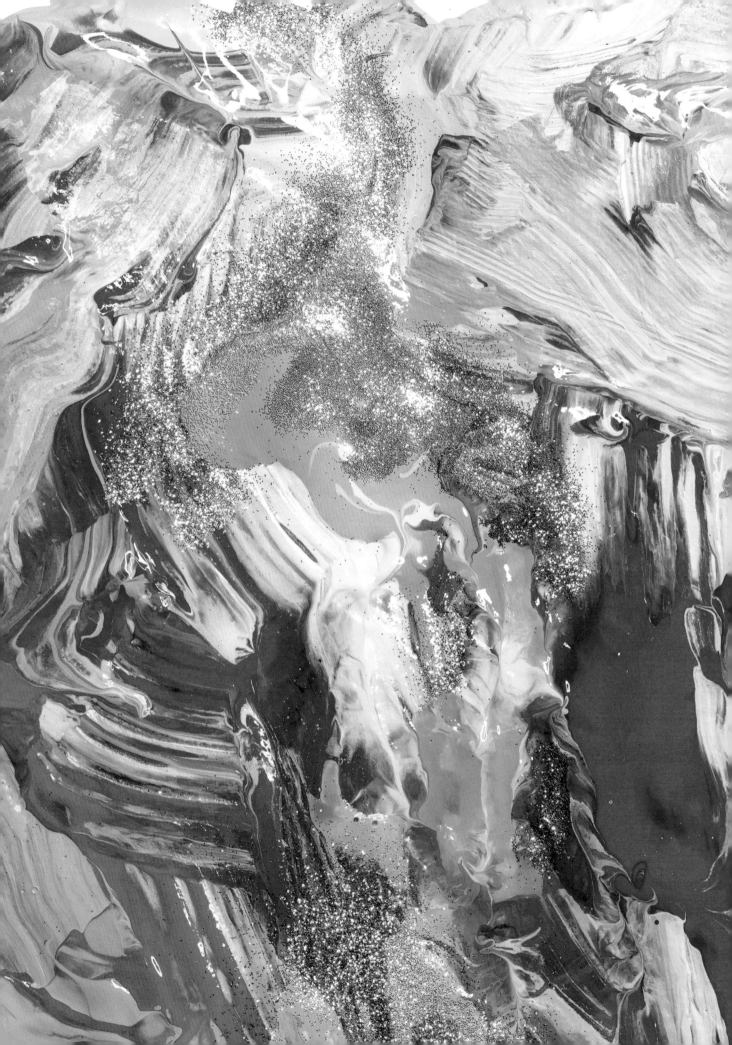

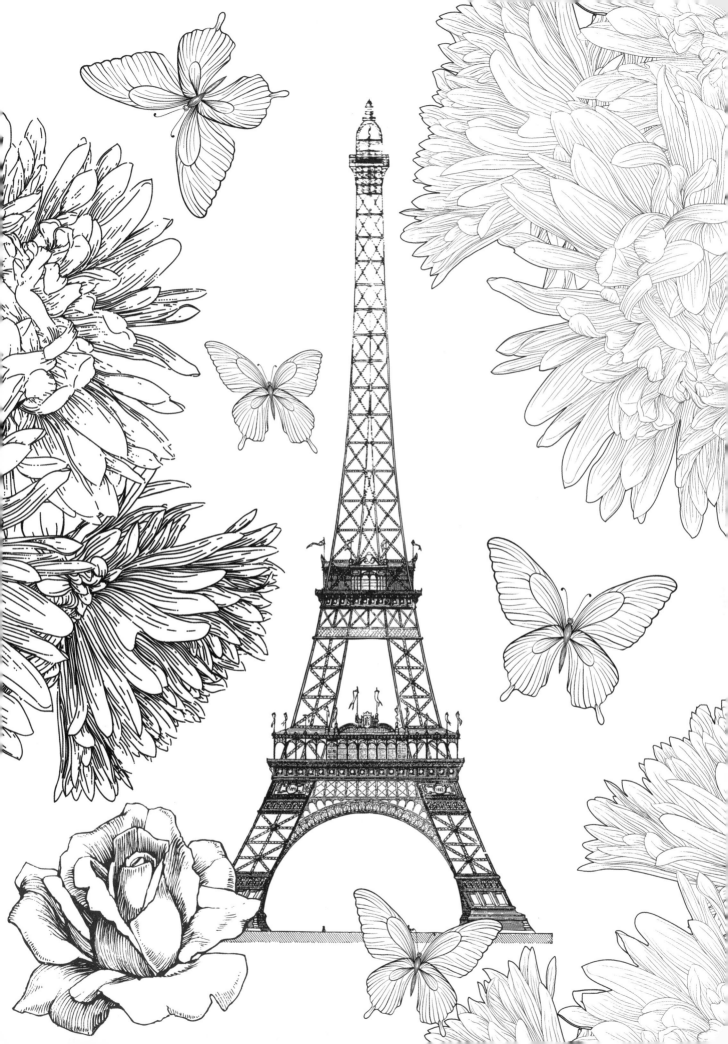

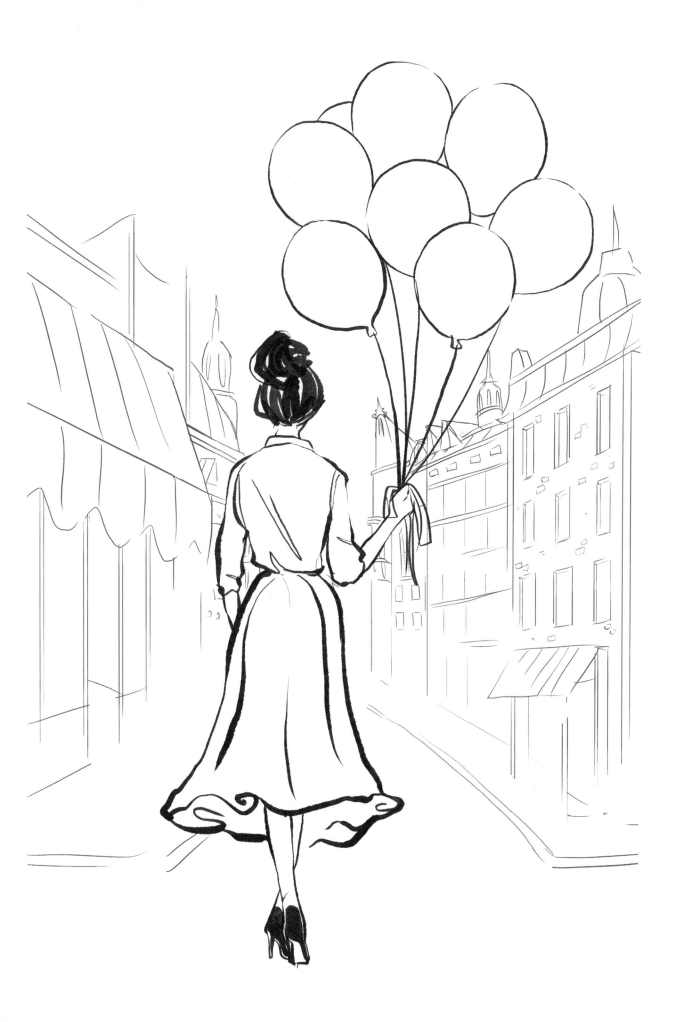

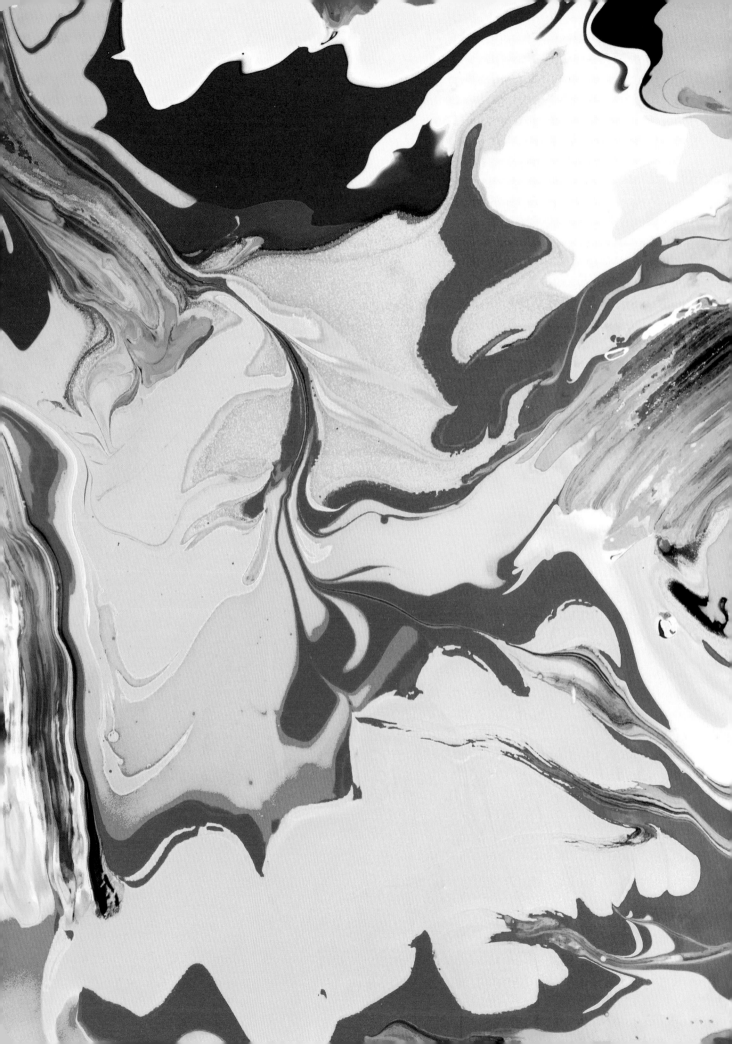

CLASSIC GLAMOUR

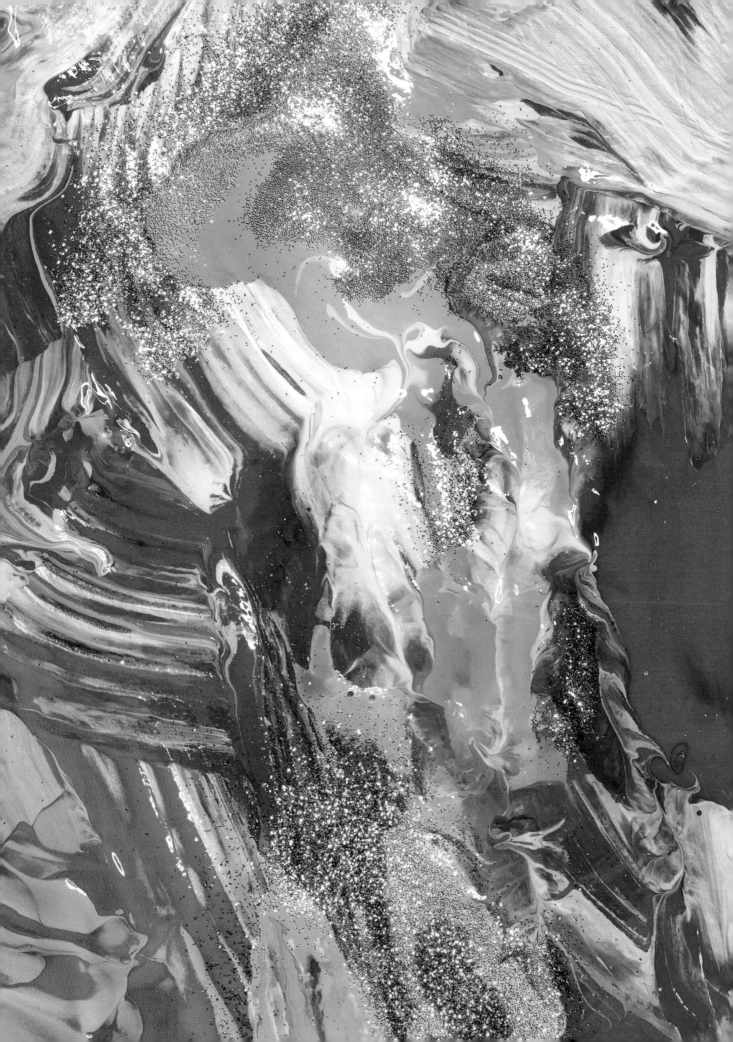

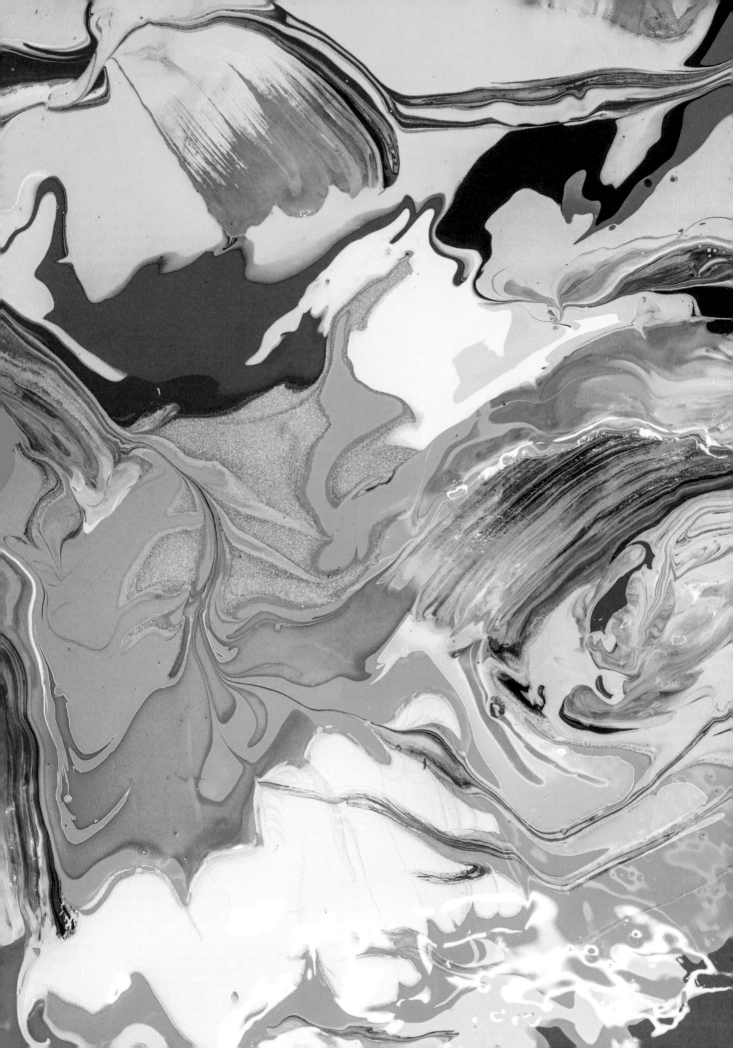

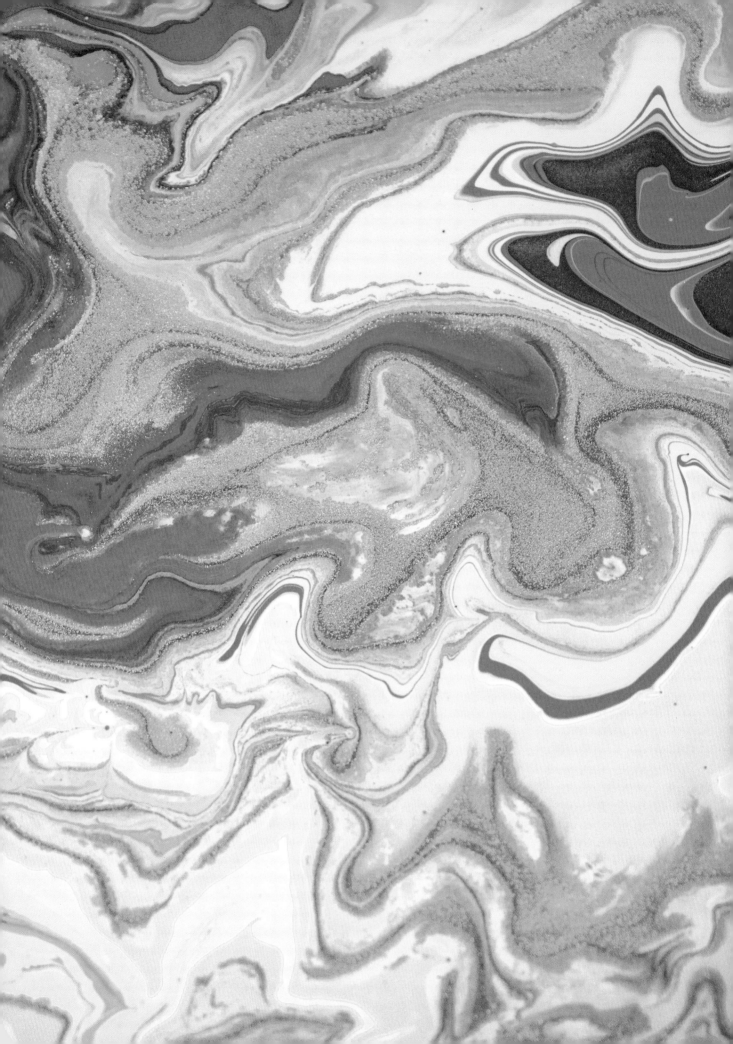

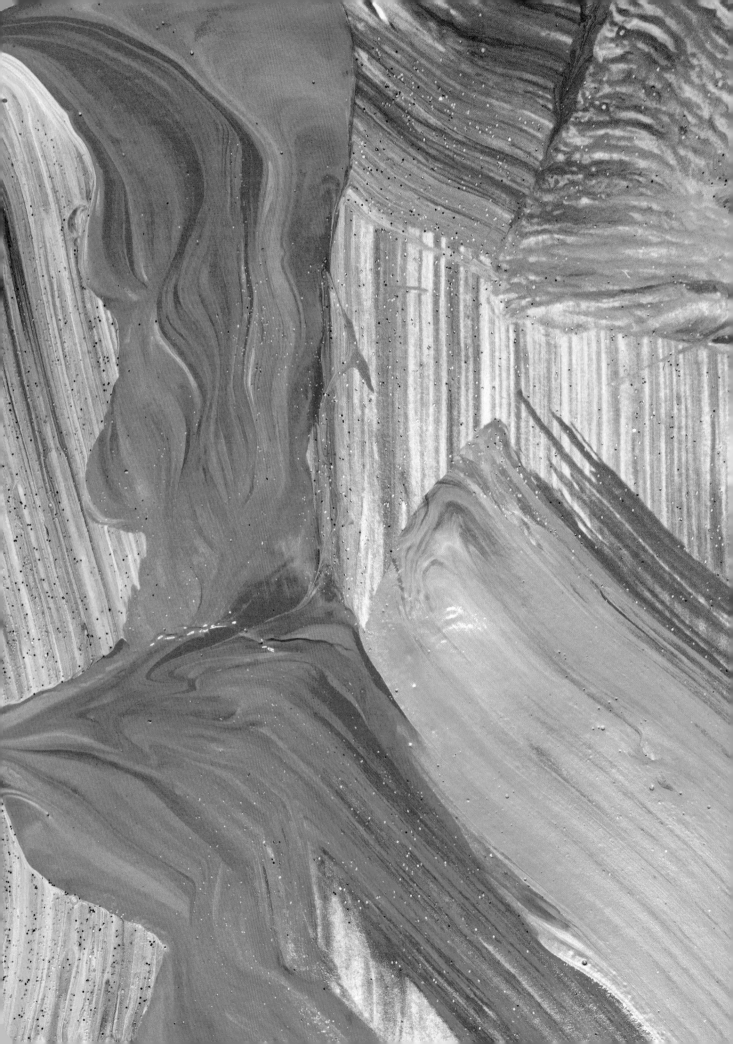

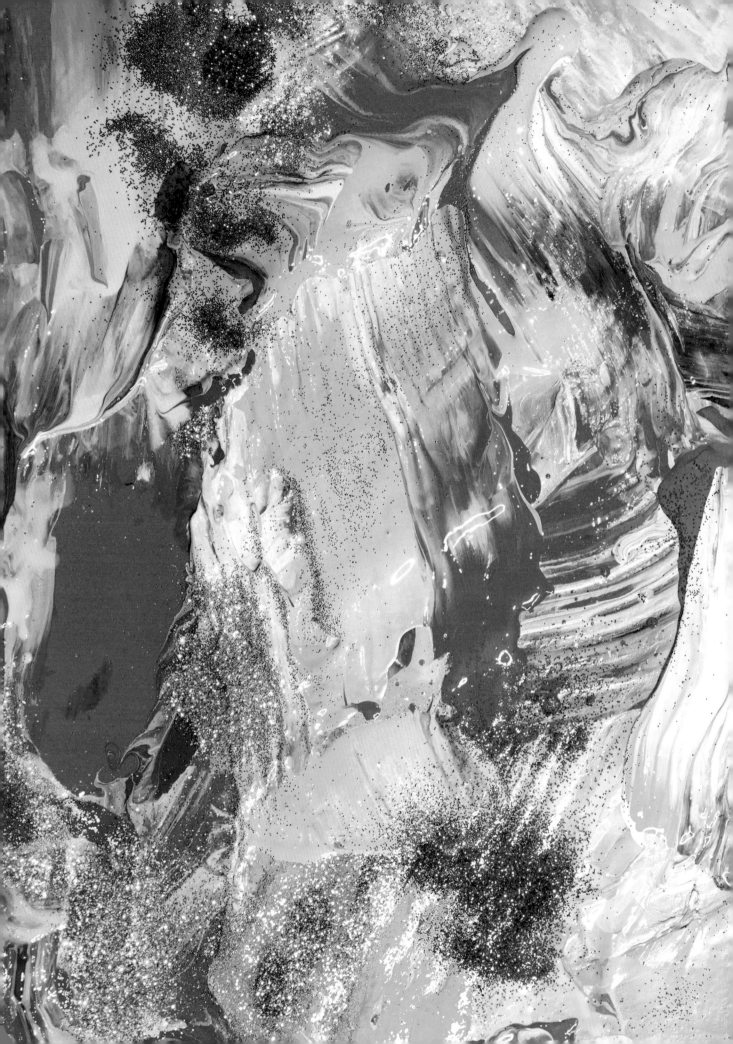

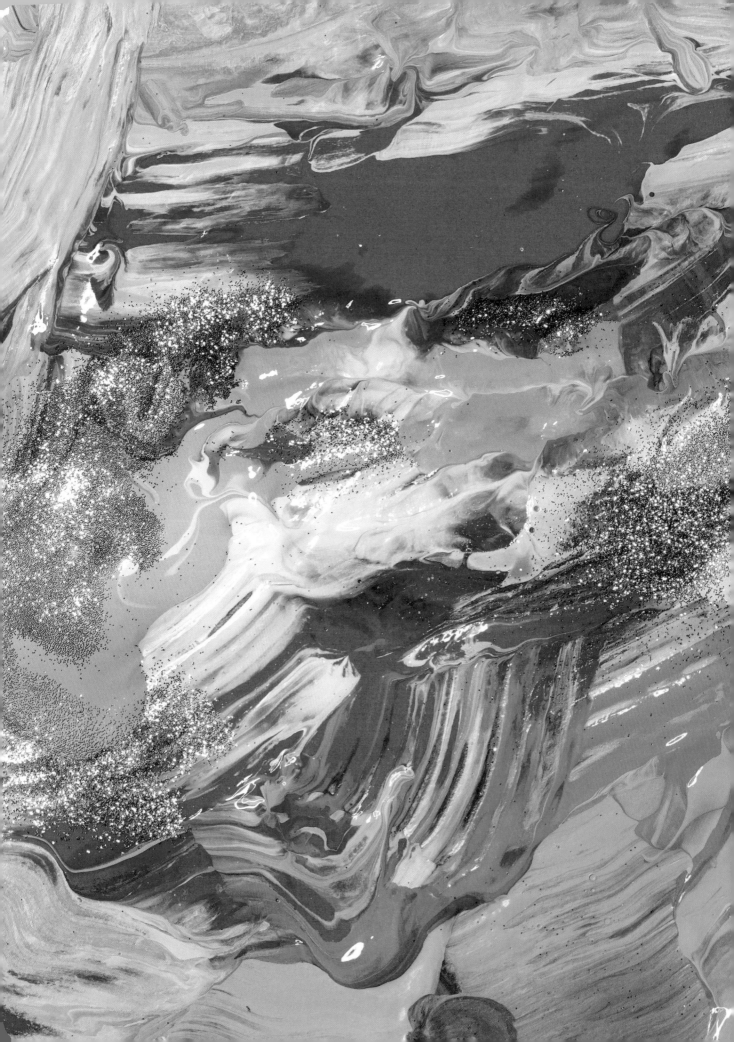

Keep your Head + heels high

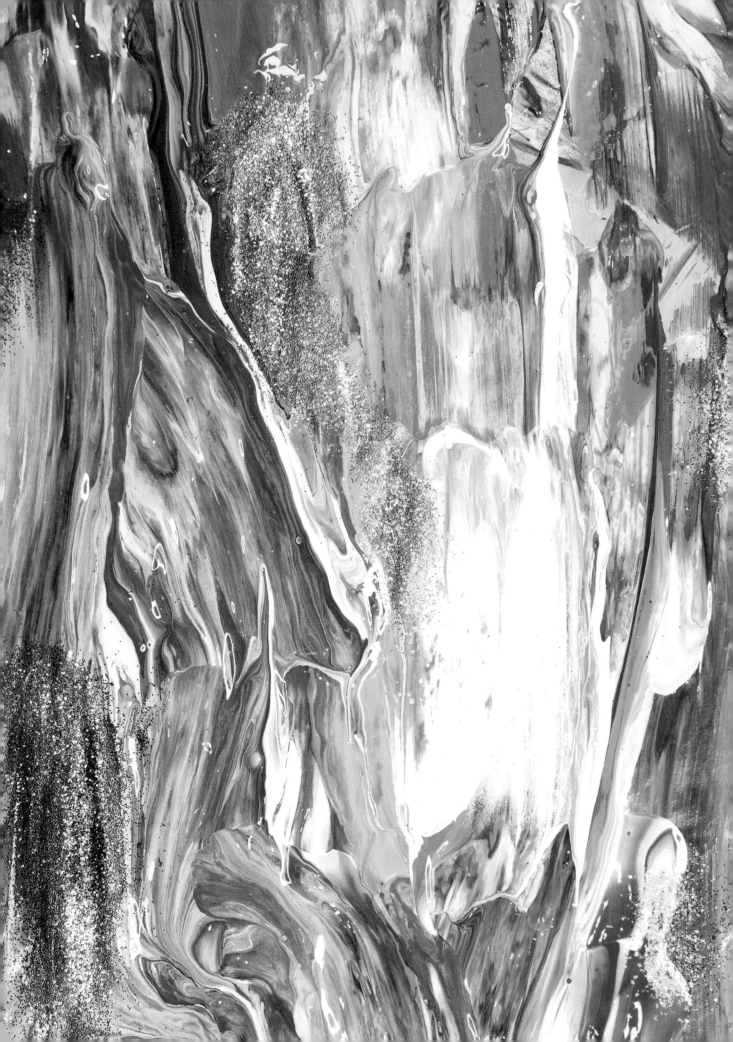

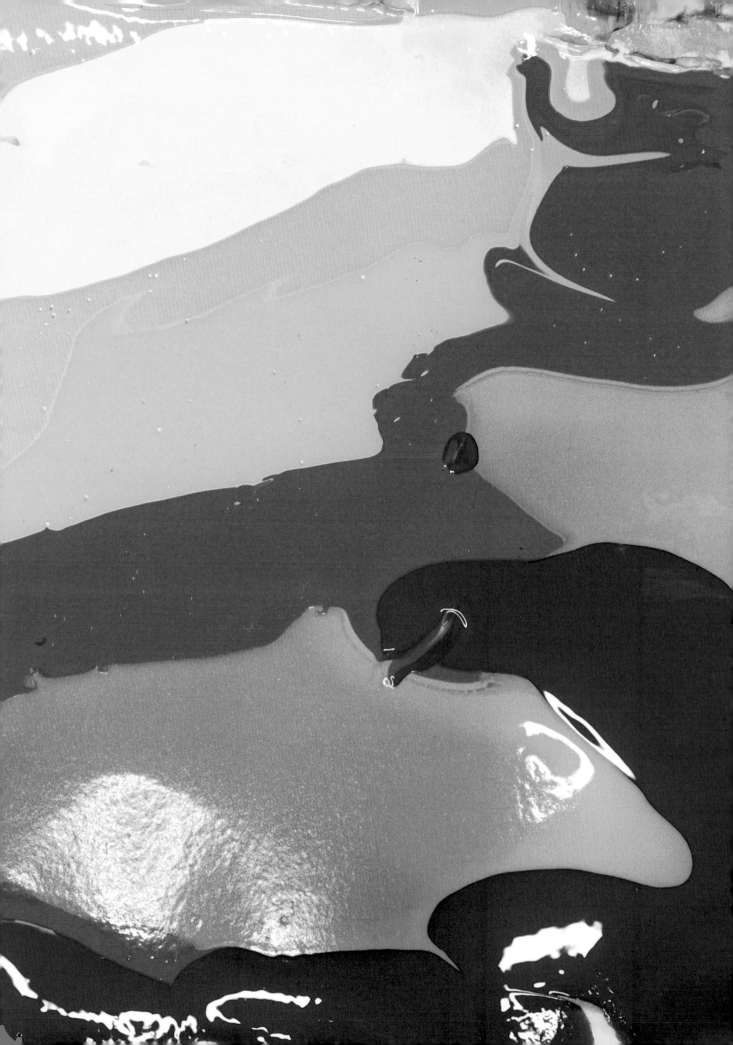

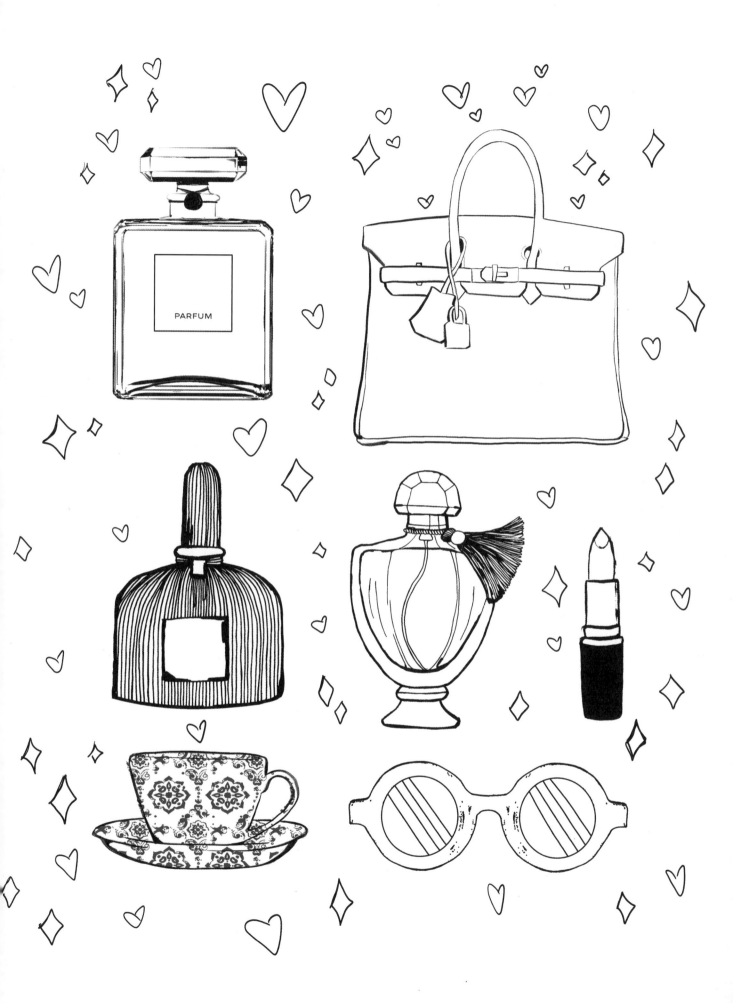

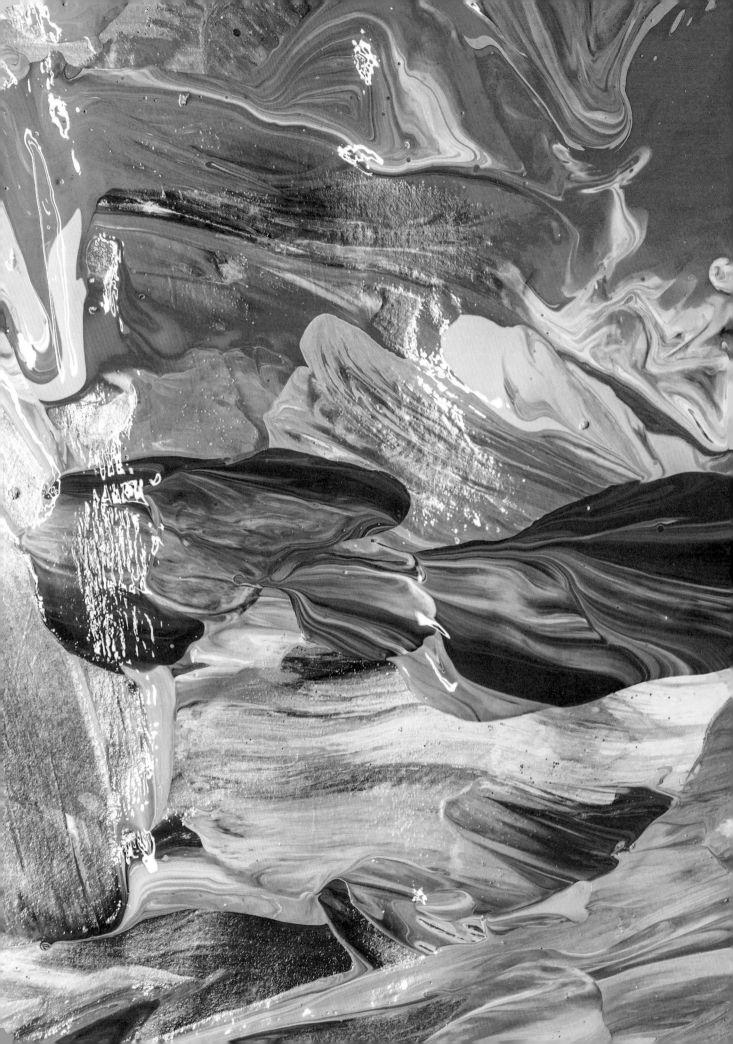

Je t'aime

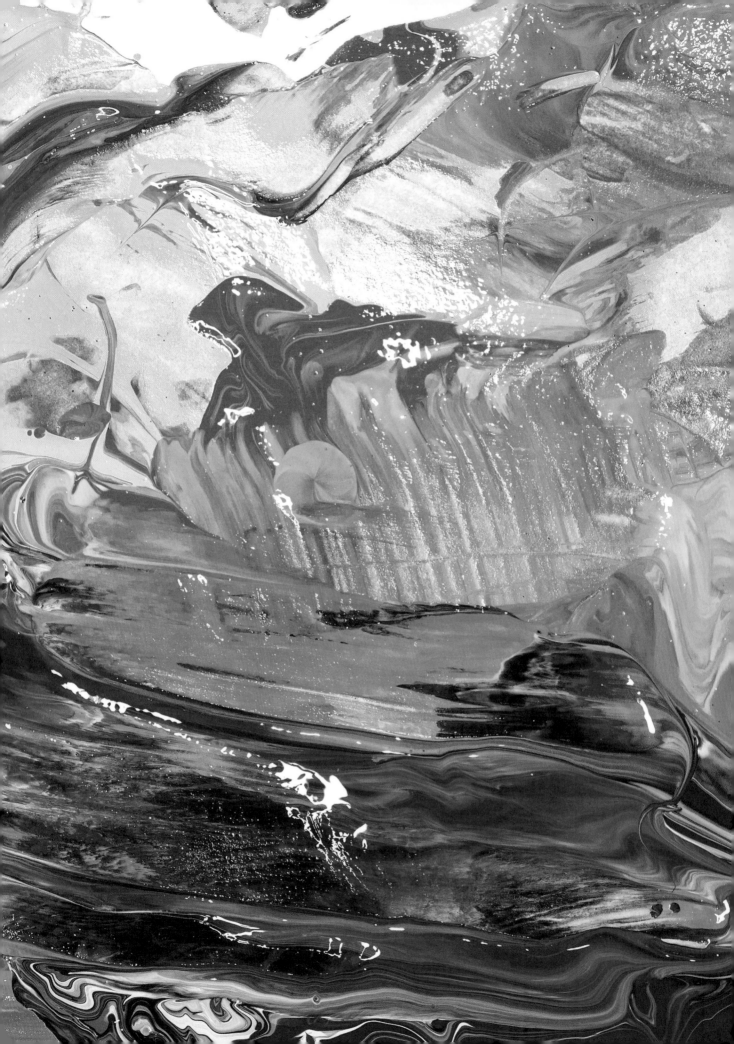

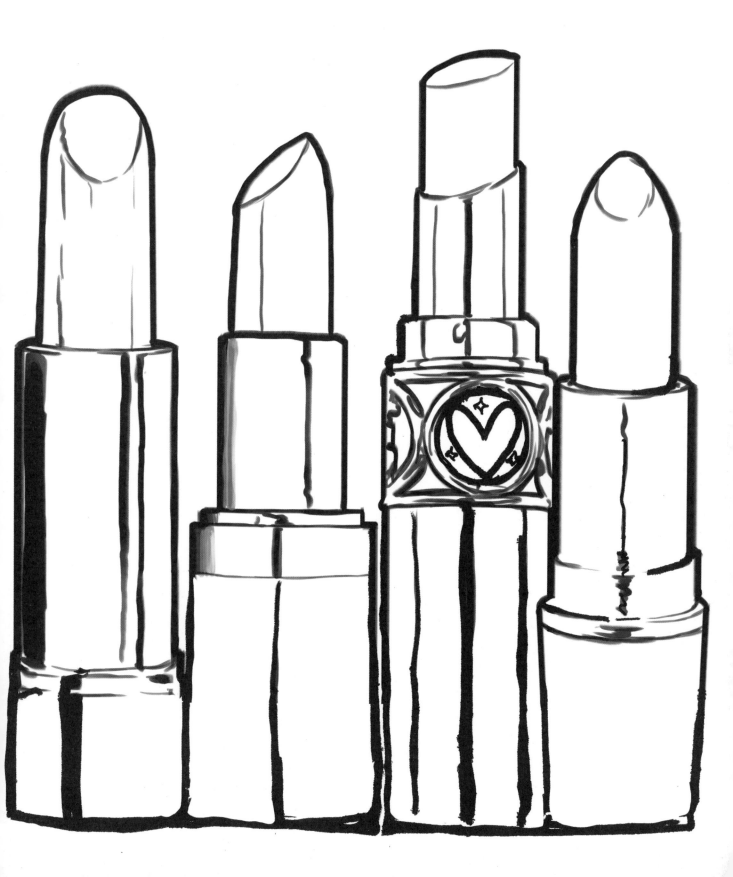

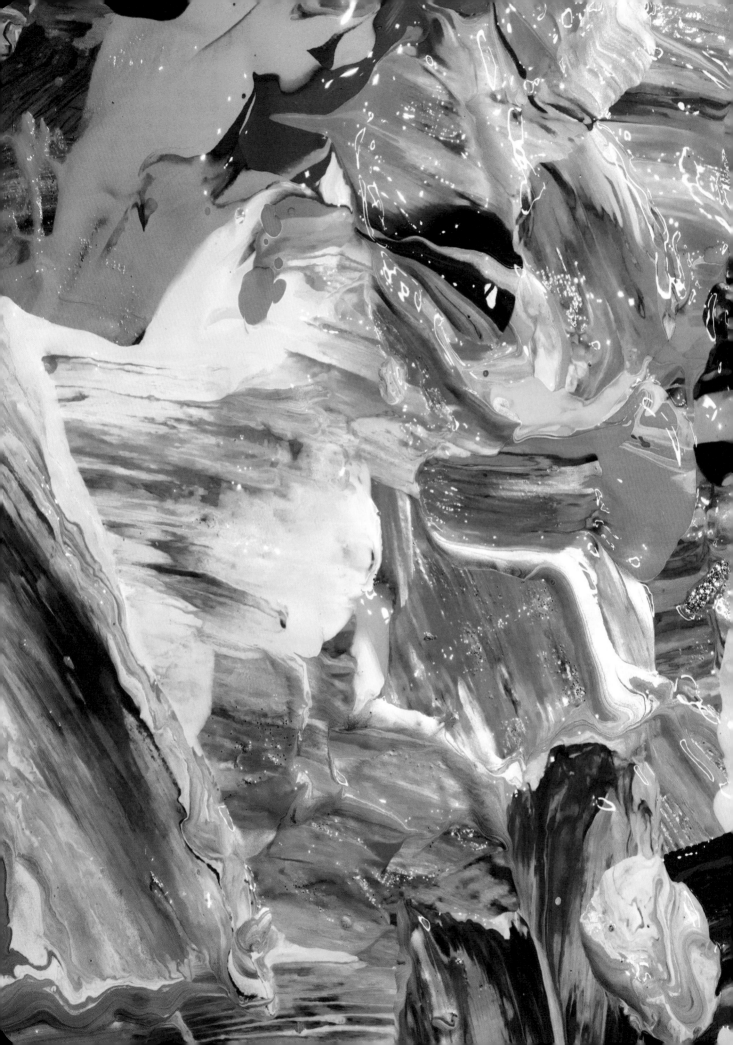

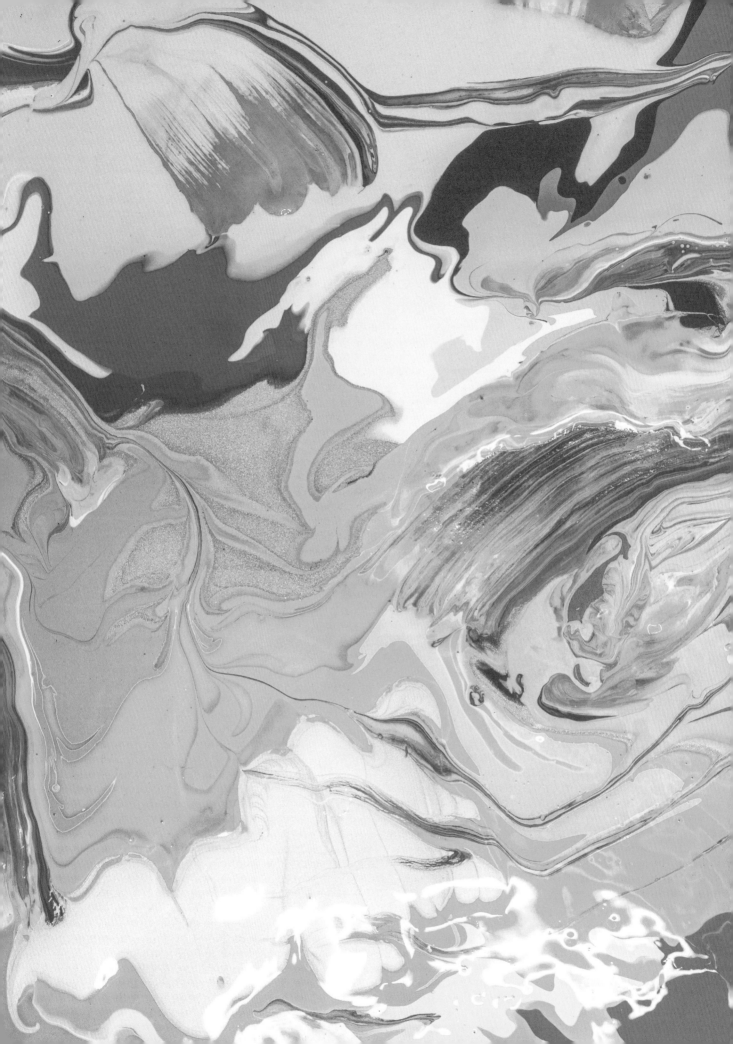

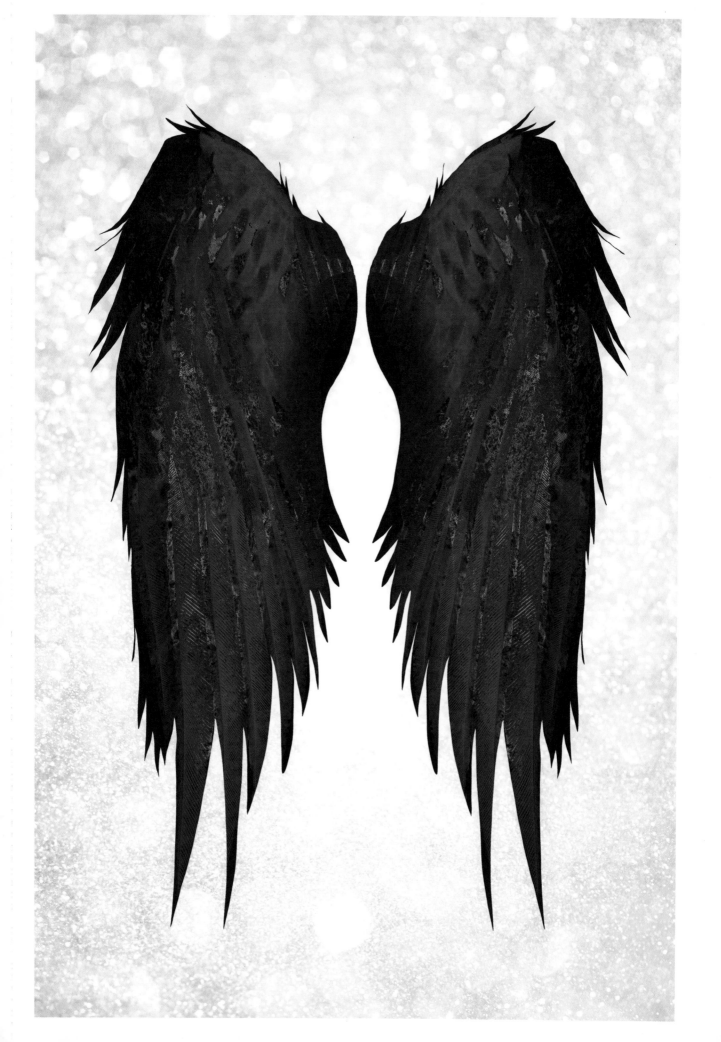

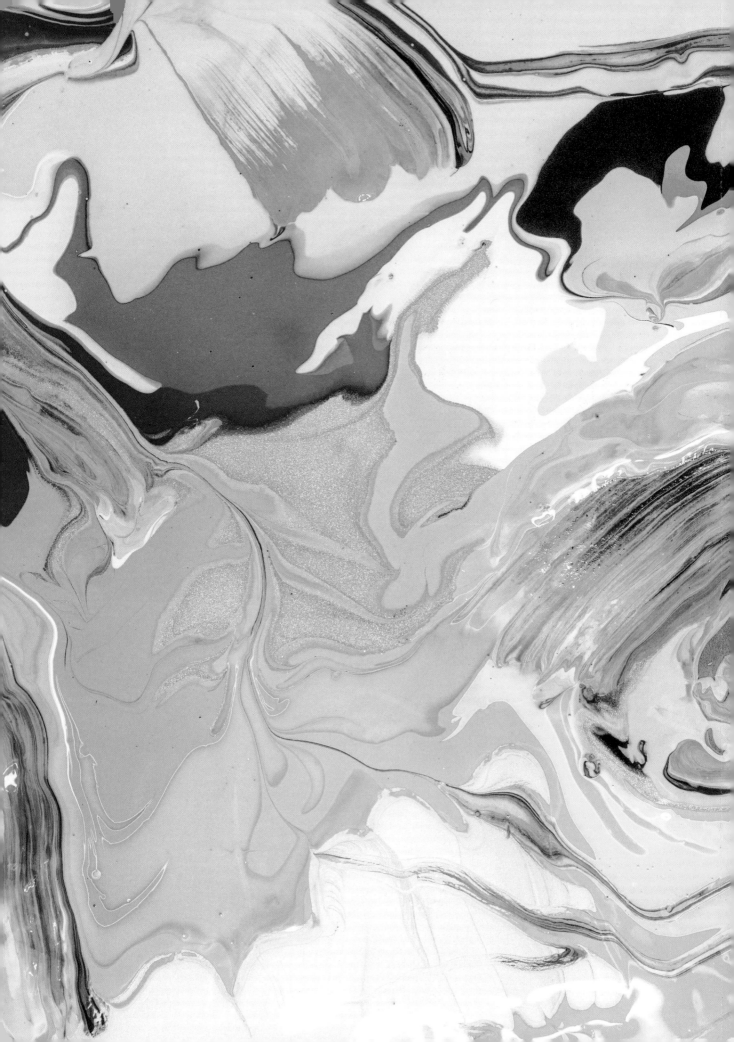

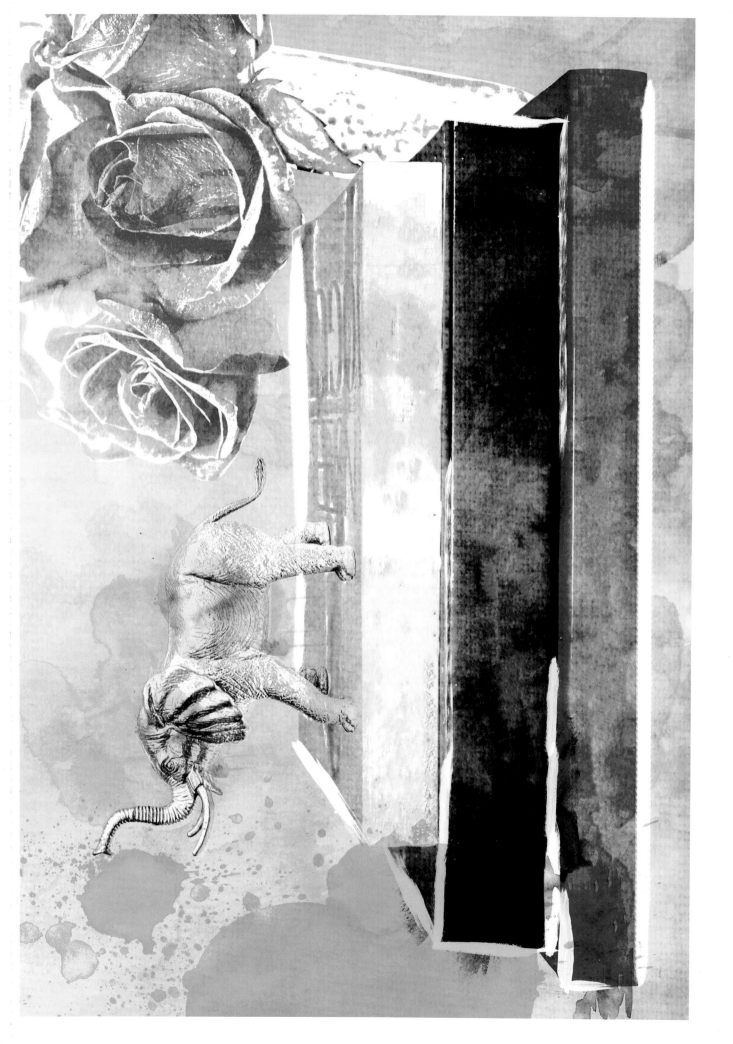

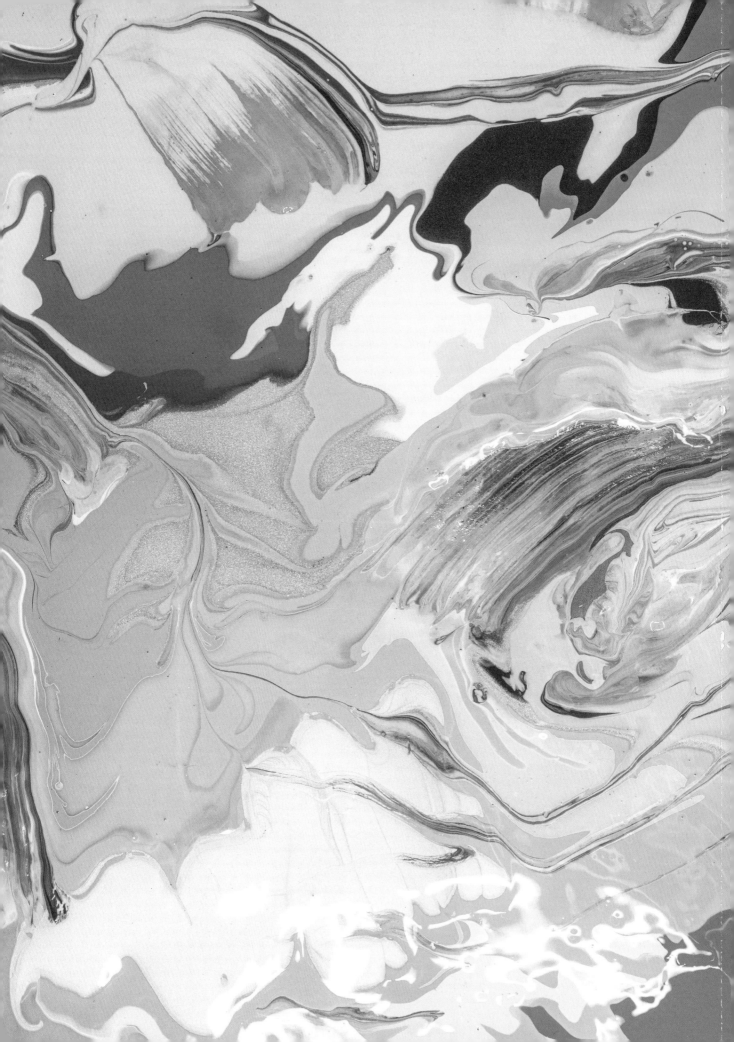

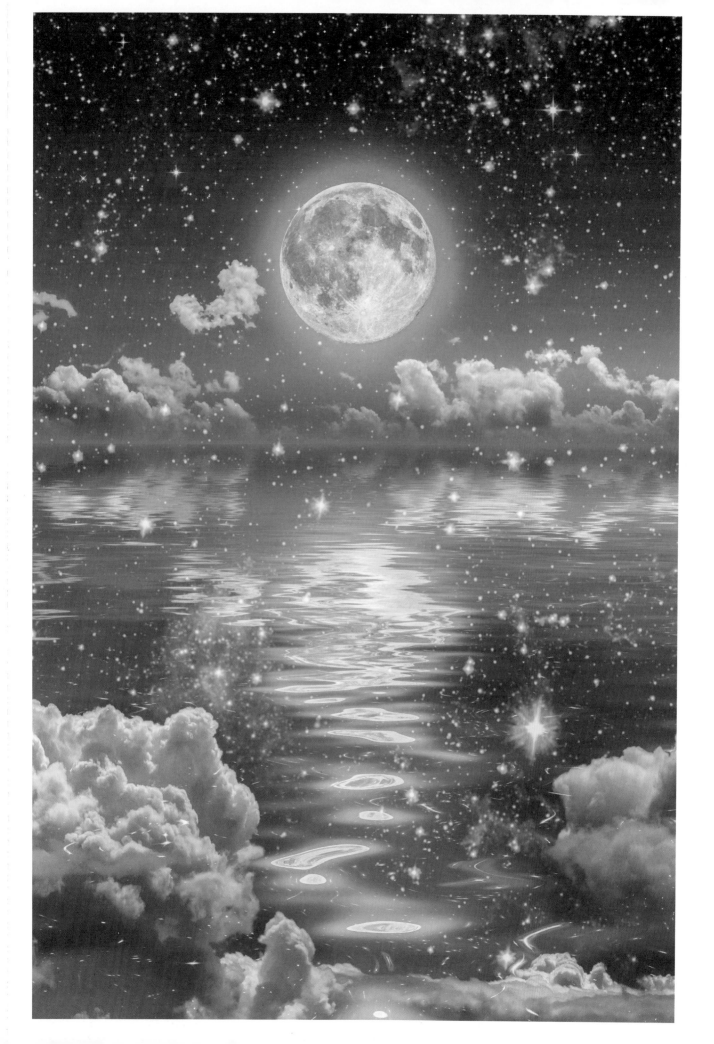

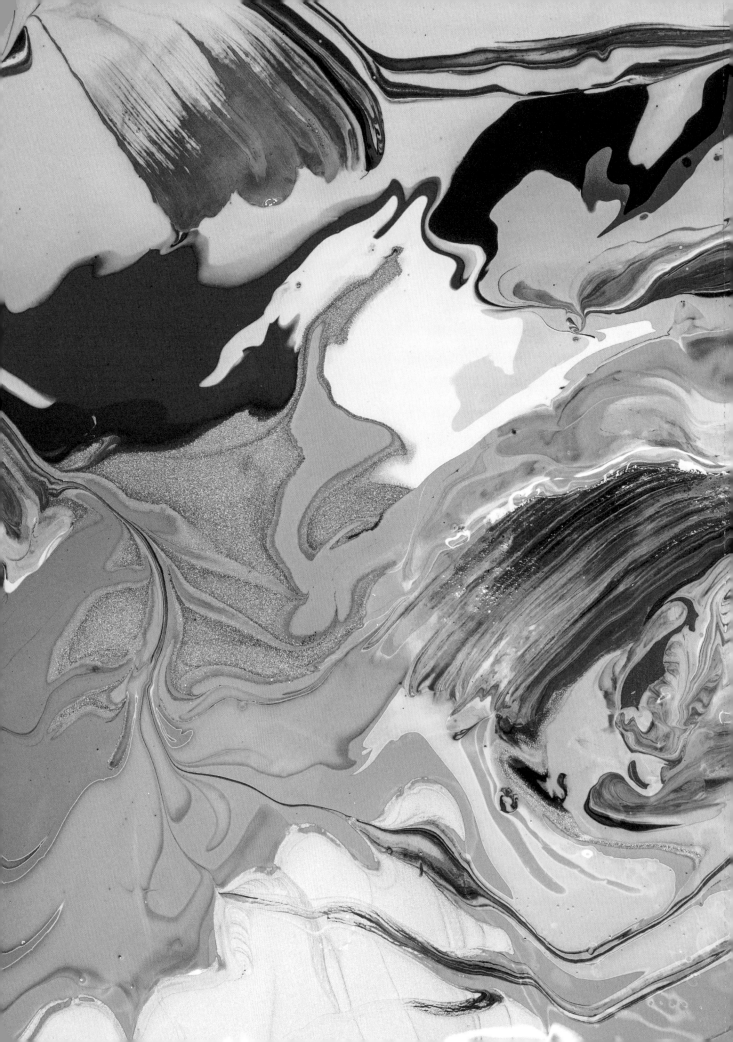

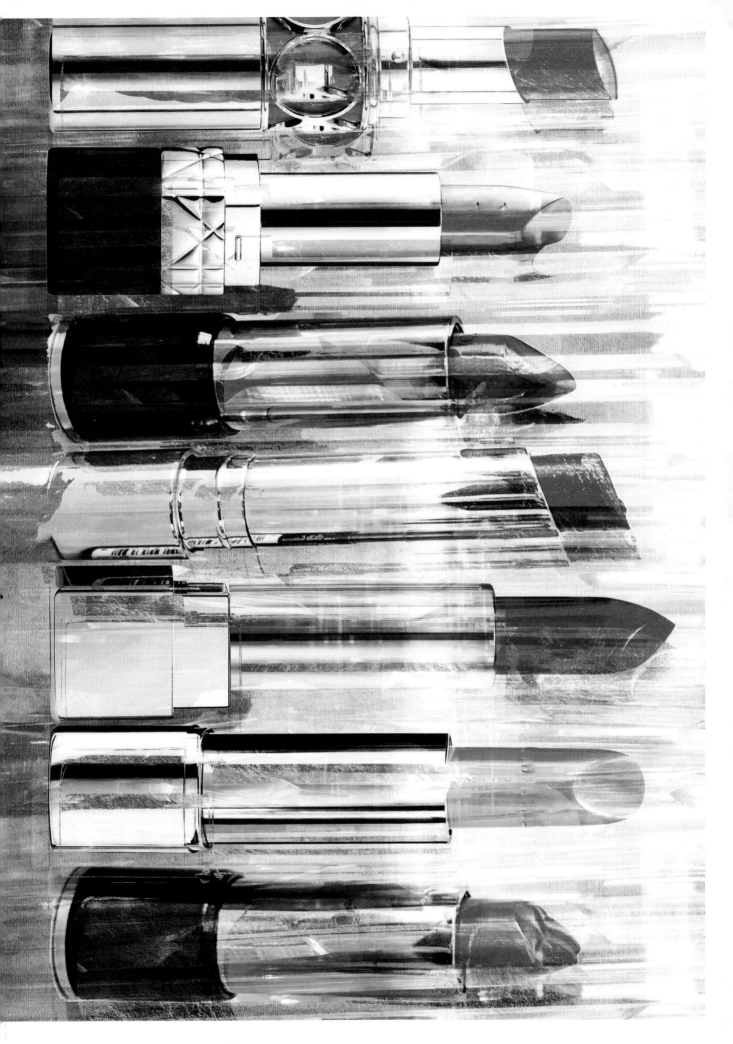

Brimming with creative inspiration, how-to projects, and useful information to enrich your everyday life, Quarto Knows is a favorite destination for those pursuing their interests and passions. Visit our site and dig deeper with our books into your area of interest: Quarto Creates, Quarto Cooks, Quarto Homes, Quarto Lives, Quarto Drives, Quarto Explores, Quarto Gifts, or Quarto Kids.

First published in 2021 by Rock Point, an imprint of The Quarto Group,
142 West 36th Street, 4th Floor, New York, NY 10018, USA
T (212) 779-4972 F (212) 779-6058 www.QuartoKnows.com

Rock Point titles are also available at discount for retail, wholesale, promotional and bulk purchase. For details, contact the Special Sales Manager by email at specialsales@quarto.com or by mail at The Quarto Group, Attn: Special Sales Manager, 100 Cummings Center Suite, 265D, Beverly, MA 01915, USA.

10 9 8 7 6 5 4 3 2 1

ISBN: 978-1-63106-758-7

Publisher: Rage Kindelsperger
Creative Director: Laura Drew
Managing Editor: Cara Donaldson
Senior Editor: Erin Canning
Cover Design: Laura Drew
Interior Design: Kim Winscher

Printed in China